POSTCARD HISTORY SERIES

Around
Phoenixville

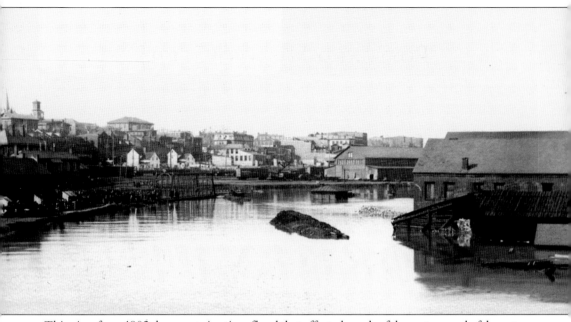

This view from 1902 shows a springtime flood that affected much of the eastern end of downtown Phoenixville. Numerous landmarks are visible in this picture, including several Phoenix Iron Company buildings, the Church Street School, the Masonic building, the Columbia Hotel, and the Phoenix Hotel. For perspective, the former iron company superintendent's building is at the left of the image, partially obscured by some smaller structures. This brownstone building has been fully restored and is one of the most prominent structures along east Bridge Street today. (Author's collection.)

On the front cover: Please see page 57. (Author's collection.)

On the back cover: Please see page 10. (Author's collection.)

Around Phoenixville

Vincent Martino Jr.

ARCADIA
PUBLISHING

Published by Arcadia Publishing
Charleston SC, Chicago IL, Portsmouth NH, San Francisco CA

Printed in the United States of America

Library of Congress Control Number: 2009927290

For all general information contact Arcadia Publishing at:
Telephone 843-853-2070
Fax 843-853-0044
E-mail sales@arcadiapublishing.com
For customer service and orders:
Toll-Free 1-888-313-2665

Visit us on the Internet at www.arcadiapublishing.com

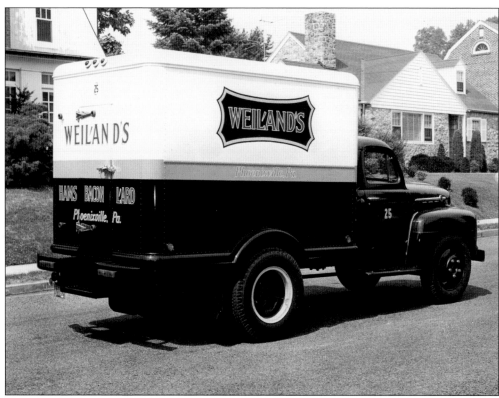

A Weiland's delivery truck is seen in this view from the early 1950s. In addition to identifying the company's location, the truck also lists ham, bacon, and lard among the firm's offerings. The Weiland's plant was located behind the homes on the northern side of the 500 block of Bridge Street. Today the former plant sits vacant and in a state of decay. (Author's collection.)

CONTENTS

Phoenixville, Pa.

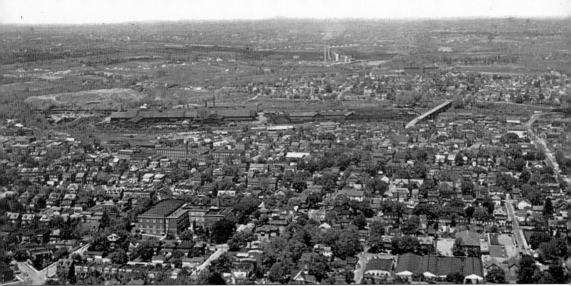

This aerial view from the late 1950s shows Phoenixville during the heyday of the Phoenix Steel Corporation and during a time of much postwar prosperity. This view is looking north, and one of the most prominent features of the postcard is the Phoenix Steel plant that stretches across the middle of the image toward the Gay Street Bridge. Samuel K. Barkley Elementary School (formerly Memorial Junior High School) is visible toward the lower left of the postcard. Near the lower right, a large garage complex can be seen. This was once located along Third Avenue across from St. Ann's Parochial School; however, the garages were destroyed by fire long ago. (Author's collection.)

INTRODUCTION

Phoenixville celebrated its sesquicentennial on the eve of the millennium, marking 150 years since its incorporation as the Phoenixville Borough in 1849. Ten years later, the community finds itself in the midst of a renaissance. This revival has come in the form of a cultural, commercial, architectural, and demographic rebirth. Progress has been made on several fronts involving the development of the community as a regional destination for working, living, and recreation. Great strides have been made in the residential, retail, and commercial sectors. Arguably, change goes hand in hand with progress. The nature of change is inevitable and sometimes regrettable. One must embrace change or be overcome by it. Any person who has maintained residence in Phoenixville for a period of less than 10 years can claim memory of many vanished structures and altered landscapes. The demolition of buildings in the name of progress has been rapid during the last decade. Additionally, fields once cultivated for crops are instead excavated for housing. With this in mind, one can only imagine the types of changes witnessed through the eyes of Phoenixville's older lifelong residents. As the famous proverb goes, "If there is one constant, it is change." However, we are fortunate that some of those who lived and worked in Phoenixville over the last century or so had the foresight to document the area's humble beginnings and ensuing development through the production of postcards. Complementing these limited-production postcards are the plethora of photographs taken by Phoenixville's residents over the years. These images represent a window into the past. The evocative nature of an old photograph can transport anyone to anyplace at anytime. Those who long for the good old days and those who crave nostalgia can be simultaneously satisfied in this regard.

Phoenixville is a town so small that one can walk at a leisurely pace from end to end in a matter of hours. Yet despite its size, it is a town rich in history, much of it wrought through its contiguity to Valley Forge and its proximity to Philadelphia, but so much more originates in itself. Initially it was the Phoenix Iron Company that put the town on the map. At its height, the Phoenix Steel Corporation (which succeeded the Phoenix Iron Company) spanned almost the entire length of town, employed many of the community's residents, supported businesses of every type, and lent itself to the development of much-needed infrastructure. In many ways, the steel mill in its varying degrees of operation has left a most indelible mark on the town it called home. Although Phoenix Steel once boasted scores of buildings around town, almost all of it has been demolished in the name of progress. These days, all that remains of the once industrial behemoth are three structures: the foundry building on north Main Street, the superintendent's building on east Bridge Street, and the pump house that sits on a barren

tract of land just north of French Creek. For those who are new to Phoenixville, it is almost unfathomable to think of what little remains of an entity the entire town was built around.

Although progress most certainly comes with a price, so too does preservation. It is desirable for the purists to see an old building adapted for reuse. However, sometimes the costs associated with retrofitting an old building for a new use can be prohibitive. When developers examine opportunities for adaptive reuse, they must employ the notion of practicality and be able to answer to their bottom lines. However, the sentimental viewpoint always favors preservation. Over the years, Phoenixville has been fortunate enough to maintain a vast majority of its original buildings, preserved and still in viable use. Many people arrive in Phoenixville as visionaries, seeing the potential that exists in renovating an old Victorian home, for example. Others arrive out of opportunity or necessity. In any event, each will make their mark in some way on the quilted fabric that is Phoenixville.

The advent of new residents over the past century has resulted in a rich cultural legacy that has left the community with several institutions rooted in ethnic and religious origin. The first wave of immigrants arrived from Europe in the early 20th century, lured by the need for work and an opportunity to experience the promise offered by the New World. This influx included Italian, Irish, Polish, Hungarian, Ukrainian, and Slavic immigrants, among many others. This provided Phoenixville with the basis for the ethnic diversity that would flourish in the coming decades. Over the last 10 years, a steady flow of immigrants from Latin America have begun to assimilate into the complex tapestry that represents the modern demographic of Phoenixville. Today the community's population easily exceeds 15,000. As such, many homes built in the 19th century have been subdivided into apartments designed to accommodate more people. Further, many former residents of the Phoenixville Borough have moved out of town into the more genteel surroundings of Charlestown or Schuylkill Township. Yet others traversed the bridge out of Phoenixville that connects Chester and Montgomery Counties and managed to settle in Mont Clare.

Steeped in a tradition of reinvention, the derivative of Phoenixville's name is wrought in reference to the mythological bird the phoenix. This creature lived for 500 years then burned itself, and from its ashes a new phoenix emerged. In literature, the term has come to symbolize something beautiful and rare. This analogy might yet prove to be a valid portent as the community embarks upon the 21st century, careful to not abandon the past but keen to embrace the promise of the future. Take a journey back in time and visit many places and structures that remain virtually unchanged over the years, some of which still operate with their original intended use. Examine with hope and admiration the many buildings that have been creatively adapted for reuse. And lastly, relive or be introduced to the multitude of places that exist now only in the hearts and minds of Phoenixville residents.

Unless otherwise noted, all images are from the author's collection.

One

A Stroll
through Town

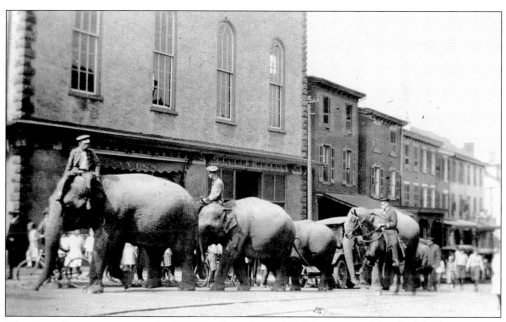

The circus has come to town in this view from the early 20th century. A herd of elephants is seen heading south on Main Street toward Church Street, passing the Masonic building on the right. Virtually all the buildings seen in the background have been preserved and still function in a commercial capacity to this day. The sight of elephants parading through downtown Phoenixville would certainly arouse as much excitement today as it did a century ago.

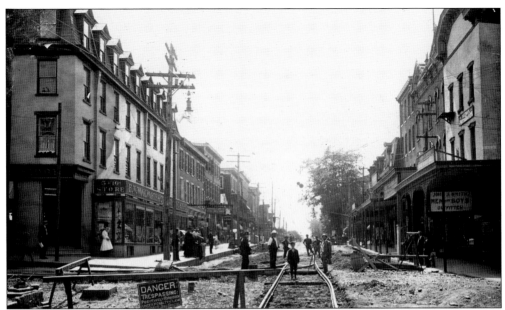

This view from just after the start of the 20th century shows Bridge Street looking west from Main Street. Trolley tracks are being laid in the street; no longer would horse and carriage be the primary mode of transportation through Phoenixville's downtown. Despite the sign in the foreground that warns against trespassing, numerous residents have made their way to the street to get a closer look.

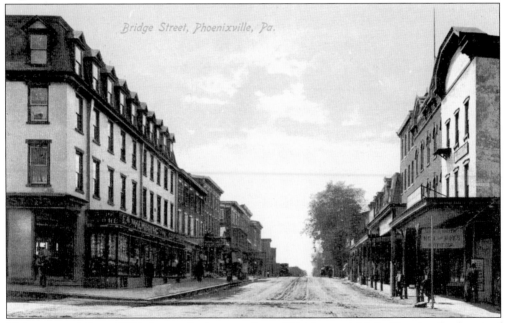

This postcard from 1906 shows the intersection of Bridge and Main Streets, the heart of Phoenixville's downtown. This view looks west on Bridge Street and shows the Woolworth five-and-dime store on the left. With the exception of the large building on the immediate right, all the structures shown here remain to this day. However, years of exterior modifications have left most of them virtually unrecognizable.

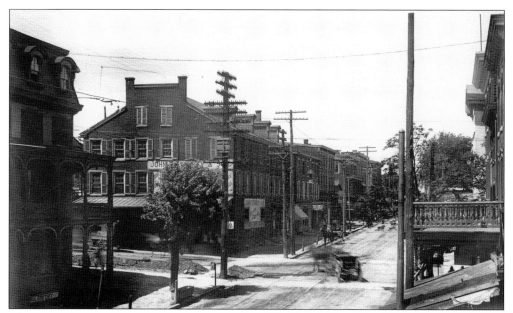

This view from 1905 was taken from the upstairs window at 185 Bridge Street. The camera captures a horse-drawn carriage rounding the corner at Main and Bridge Streets. The former Phoenix Hotel can be seen at the left of the image. Although the hotel was torn down in 1949, many of the structures visible in this shot remain to this day, albeit with extensive interior and exterior modifications.

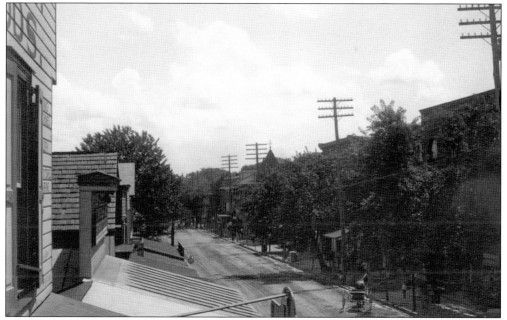

This view was also taken in 1905 from the vantage point of 185 Bridge Street; however, this shot looks in an eastern direction down the street. The trees lining the south side of the street were removed long ago, yet virtually all the buildings behind them remain to this day. Toward the center of the image, the top of the Columbia Hotel is visible. Additionally, all porches that hung over the Bridge Street sidewalk were removed decades ago.

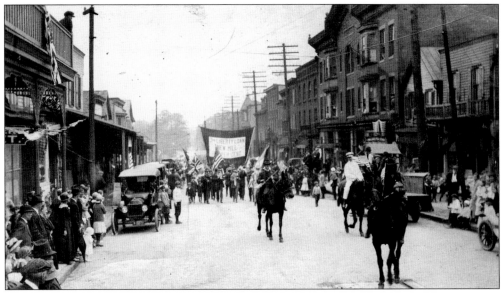

These images from 1917 show a parade heading west on Bridge Street toward the intersection with Main Street, passing the old Wall Block Inn on the right side of the photograph. Most of the buildings visible to the immediate right were destroyed by fire in the late 1980s, while the others in view remain to this day. This former parade route is one of the busiest thoroughfares in Phoenixville today, a virtual center of arts, entertainment, restaurants, bars, and commerce. As is evident in this view, parade-goers and participants alike wore dresses, jackets, ties, and hats. Although Phoenixville stills hosts numerous parades throughout the year, the attire is certainly more casual these days. (Below, courtesy of the Seacrist family.)

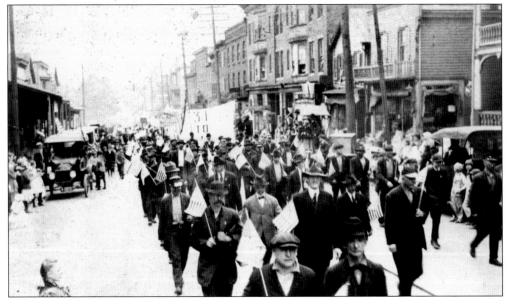

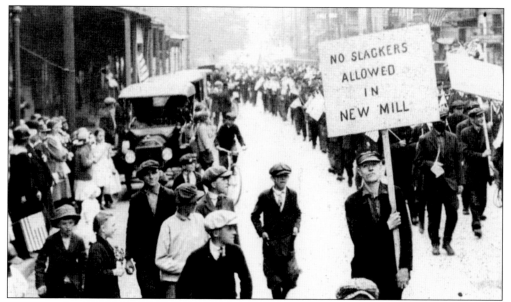

This view from 1917 shows the same parade as depicted on the preceding page. A long line of marchers is led by a man holding a sign that admonishes, "No Slackers Allowed in New Mill." In the foreground, several young boys are nattily attired as well as the parade participants, a sharp contrast from the more relaxed environments akin to Phoenixville's modern parades. (Courtesy of the Seacrist family.)

This 1905 photograph was taken from a rear window at 185 Bridge Street. Looking beyond the shed in the foreground, one can see some of the Phoenix Iron Company's buildings. Off in the distance in the upper right corner of the image is the Pennsylvania House Hotel located on High Street at the terminus of north Main Street. Looking toward the top center of the image are two prominent former homes located along Vanderslice Street, both of which remain today in the form of apartment conversions. The structure visible in the upper left corner of this view is the former silk mill located along Franklin Avenue at Grant Street.

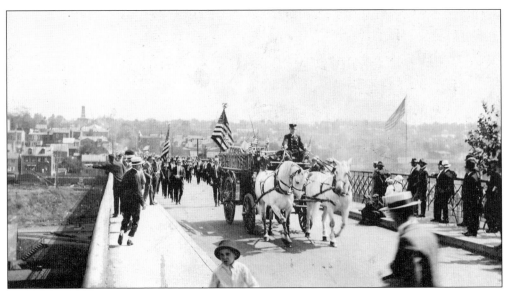

These views show a World War I–era parade heading north across the Gay Street Bridge toward Vanderslice Street. The large building in the background that is advertising Gold Medal Flour in the image below is the Colonial Theater, located on Bridge Street. Most of the structures visible in the background have been preserved to this day, including the row of mid-19th-century homes along Mill Street. The bridge seen here was replaced in 1924, several years after these photographs were produced. In 2009, the 1924 bridge had been removed and construction on a modern span had commenced. (Courtesy of the Seacrist family.)

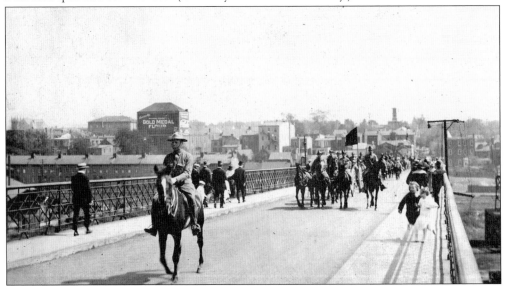

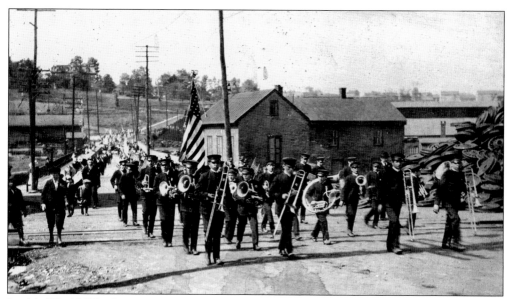

In this World War I–era view, a parade makes its way south on Main Street toward Bridge Street, passing by some Phoenix Iron Company buildings on both sides of the street. Although the origin of the materials on the right side of the image remains a mystery, it is possible that scrap metal was being collected for the war effort. Today a new bridge crosses French Creek in the background, and almost all the Phoenix Iron Company buildings have been demolished. (Courtesy of the Seacrist family.)

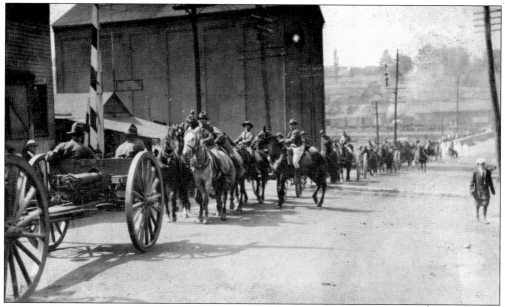

This World War I–era view shows a parade heading south across the Main Street Bridge toward Bridge Street, showing some of the former Phoenix Iron Company buildings in the background. Today this intersection still sees its share of parades, but the old buildings were torn down long ago in conjunction with the demise of the iron company's successor, the Phoenix Steel Corporation. The large building that dominates the image was located along Main Street at Taylor Alley and housed the infirmary, among other functions. (Courtesy of the Seacrist family.)

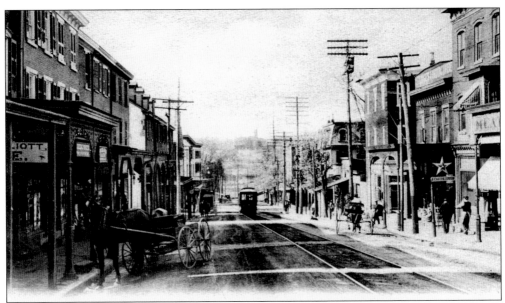

This view from 1905 shows the Main Street hill, looking north from Church Street. Almost all the buildings seen in this postcard remain to this day, albeit with numerous interior and exterior modifications. This block of Main Street has managed to retain its commercial character in the century since this postcard was produced. However, it is highly unlikely that one would ever see a horse and carriage awaiting its owner in this day and age.

This view from the early 20th century shows the Masonic building, easily one of the town's most prominent structures and a survivor of time and progress. This building was constructed in 1868, and at the time of this photograph, a purveyor of boots, shoes, and rubbers occupied the storefront facing Main Street at the corner of Church Street.

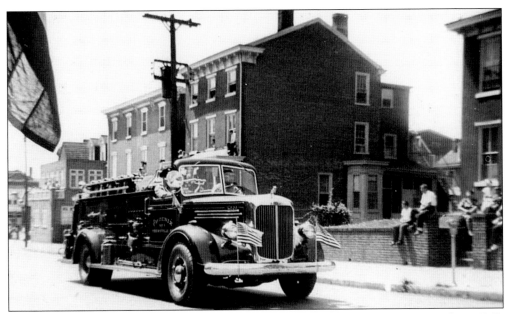

Phoenixville's centennial parade makes its way east on Church Street in this view from 1949. The Phoenix No. 1 Fire Company's Mack fire truck features prominently in this image, along with several buildings that all remain on the north side of Church Street to this day, with one notable exception. The large building just out of view to the right was torn down long ago to make way for a borough parking lot. (Photograph by Viola Batzel.)

This image shows another view of Phoenixville's centennial parade and is inclusive of several homes and businesses that comprise the north side of Church Street. In this photograph, the large Masonic building anchors the block at the top of the hill, fronting Main Street. Despite the elapse of six decades, all the structures present in 1949 remain in place today and are easily recognizable. (Photograph by Viola Batzel.)

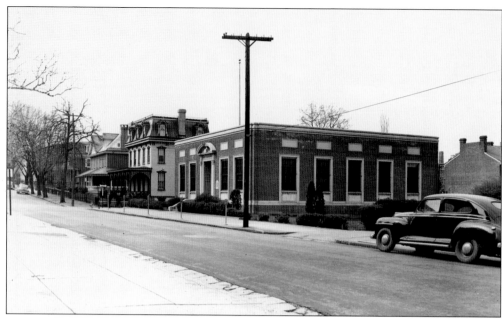

This view from the late 1940s looks south on Gay Street from in front of the post office. The prominent brick structure in this picture is the former Bell Telephone Company building. Although the parking meters visible in front of the building are long gone, the many homes seen beyond the intersection with Hall Street remain today.

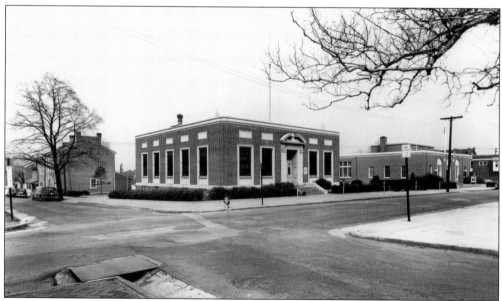

This photograph was taken from the southeast corner of Gay and Hall Streets in the late 1940s. In addition to the Bell Telephone Company building, the Phoenixville Post Office is visible to the right. Toward the left side of the image, the houses visible along Hall Street are all still occupied.

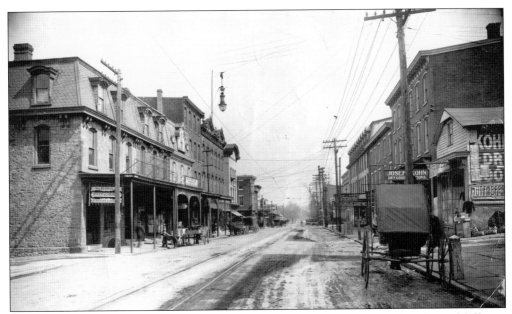

An early-20th-century view of Bridge Street looks east from Bank Street. A variety of different businesses line both sides of the thoroughfare looking toward the intersection with Main Street. Just beyond the horse-drawn carriage is the Joseph Kohn Dry Goods store. With the exception of the porches hanging over the sidewalk, most of the buildings shown still retain much of their original structure.

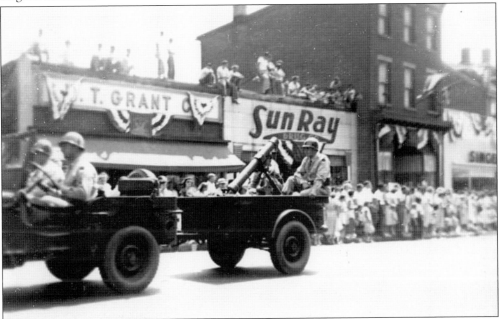

This view from 1949 captures Phoenixville's centennial parade as it heads east through the 200 block of Bridge Street. All the buildings visible in the background are still there today, although they are occupied by different enterprises. However, in 1949, they were the W. T. Grant Company variety store, the SunRay Drug Company, an unidentified store in the third storefront, and the Singer sewing machine store at the right. (Photograph by Viola Batzel.)

19

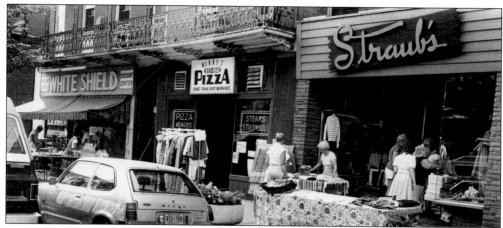

This view from the early 1980s shows a sidewalk sale occurring in Bridge Street's 200 block, along the south side of the street. From left to right are White Shield, a purveyor of discount sundries, Manny's Pizza, and Straub's ladies' clothing store. Although all three structures remain today, they are occupied by different businesses. Each of the entities shown here are but a memory of Phoenixville's recent past.

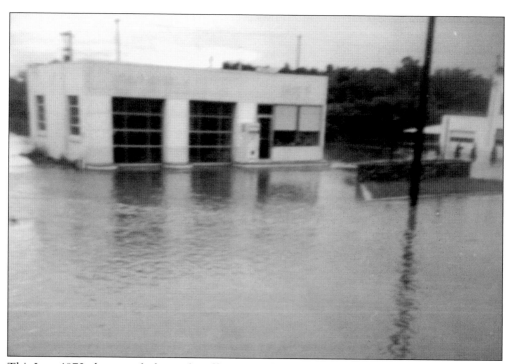

This June 1972 photograph shows the effect wrought by Hurricane Agnes on the eastern end of Bridge Street. This former gas station, located adjacent to the Mansion House restaurant, was flooded by the Schuylkill River, which had crested days before. No subsequent hurricane has caused damage to Phoenixville on the scale of Hurricane Agnes. (Courtesy of Thelma Alexander.)

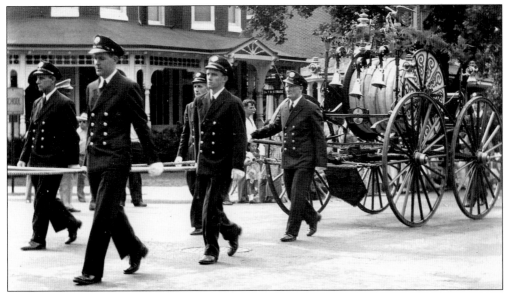

This image from the late 1940s shows the annual Dogwood Parade heading south on Main Street at the intersection with Third Avenue. In this view, several members of the fire department are guiding vintage firefighting apparatus along the parade route. In the background, the home and office of Dr. Struse is visible on the northwest corner of the intersection. This home was one of many locations used in the 1958 Steve McQueen film *The Blob*. (Courtesy of the Lessig family.)

A 1988 photograph taken from east Bridge Street at the base of Church Alley shows the Columbia Hotel to the left and several buildings that have been cordoned off and are awaiting demolition. The storefront to the left of the Columbia Hotel's parking lot was home to a cigar shop and social club called Bluejays. Today a condominium has risen in this place, anchored by a large bar and restaurant on the ground floor.

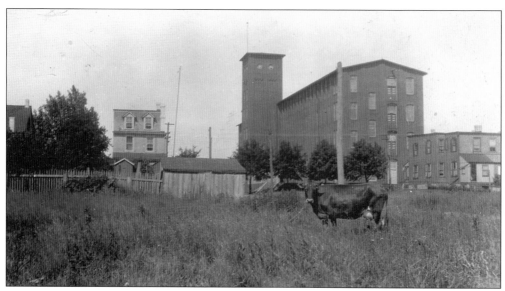

A ruminating cow gazes menacingly at the camera in this view from the early 20th century. Amazingly enough, this bucolic scene is actually Phoenixville's north side and today comprises the backyard of a house facing Franklin Avenue at Grant Street. The prominent building in the background originally functioned as a silk mill and has been repeatedly built upon over the years. Today a cow would seem quite out of place in this dense residential neighborhood.

This image from the 1980s shows an old roadside stand that sold locally grown produce. This was located along Fillmore Street between Franklin Avenue and Cromby Road on Phoenixville's north side and was a vestige of the area's rich agricultural past. In this autumn view, the stand is empty, and a rusted delivery truck sits just behind it. This structure was destroyed by fire in the late 1990s and had been out of use for quite some time at that point.

Two

Business and Industry

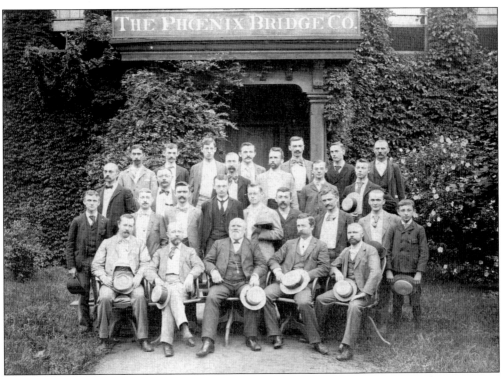

This real-photo postcard from the early 20th century primarily shows the executive management group of the Phoenix Bridge Company gathered in front of its headquarters on east Bridge Street. Phoenix bridges were constructed not only throughout the United States but beyond the country's borders as well. To this day, several original Phoenix bridges survive, most notably the one located next to the foundry building along Main Street.

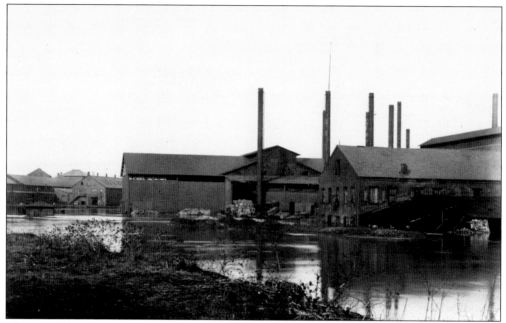

This image from 1902 shows several structures on the grounds of the Phoenix Iron Company that have been consumed by floodwaters. Toward the left side of the image, the roof of the foundry building is barely visible from its location along Main Street. All other structures in this view were torn down in the late 1980s, commensurate with the demise of local steel production.

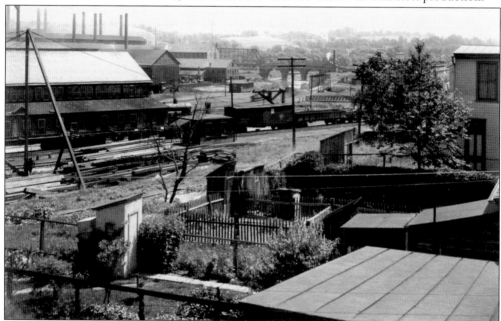

This view was taken in 1905 and looks north toward the Phoenix Iron Company property located behind the 100 block of Bridge Street in Phoenixville's downtown. Beyond the railcars and myriad buildings visible in the background, this image is also interesting in that each of the backyards shown contains an outhouse, a reminder of the distant past when indoor plumbing was a luxury enjoyed by only the wealthiest of homeowners.

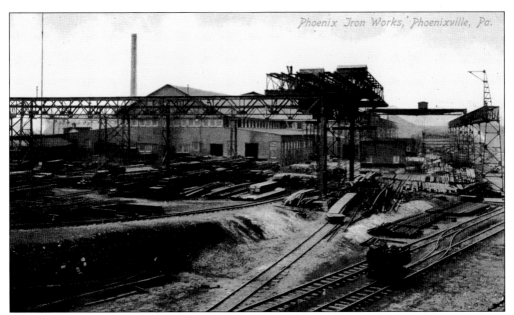

This postcard from 1906 shows a view of the Phoenix Iron Works, as seen from Main Street. This image provides some insight not only to the intricate network of structure that was integral in the successful operation of the facility but also to the numerous train tracks that traversed the site in so many directions. Today virtually everything visible in this view is gone. The tract of land that housed this industrial behemoth sits fallow amid the town's redevelopment.

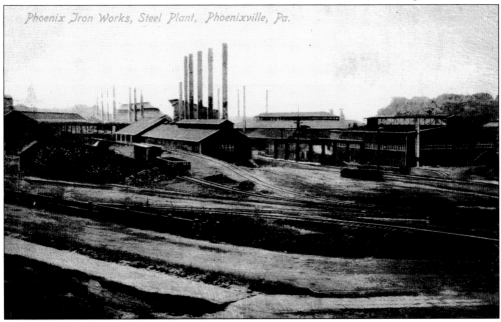

A 1907 postcard looks in an eastward direction at the Phoenix Iron Works from the vantage point of Main Street. In familiar prose, virtually everything visible in this image has disappeared from Phoenixville's landscape. The property sits idle, awaiting eventual development. For context, the two spires barely visible in the distance to the left of the tree line were an architectural element that once adorned the roof of the former Philadelphia and Reading Railroad passenger station.

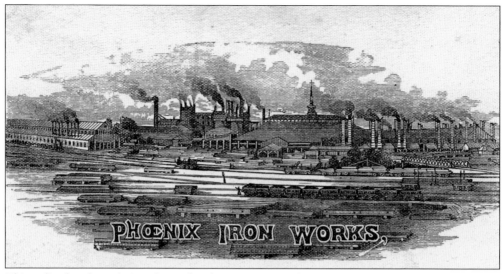

This stylized trade card view shows the Phoenix Iron Works as it appeared in the late 19th century. At its height, the complex spanned the length of the town and employed many Phoenixville residents. As it grew in size, so too did the community. Today virtually all the buildings seen here are gone, victims of an economic downturn. The only structures remaining from the iron company days are a foundry, a superintendent's building, and a brownstone pump house.

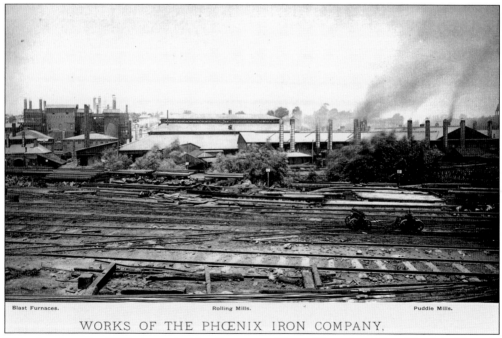

This view from the 1880s shows the blast furnaces, rolling mills, and puddle mills of the Phoenix Iron Company. This photograph was taken from east Bridge Street, looking north. For perspective, the top of St. Mary's Church is barely visible toward the middle of the picture, just to the left of the large building that dominates the complex. Approximately 100 years after this image was produced, virtually everything visible in this landscape would be gone.

26

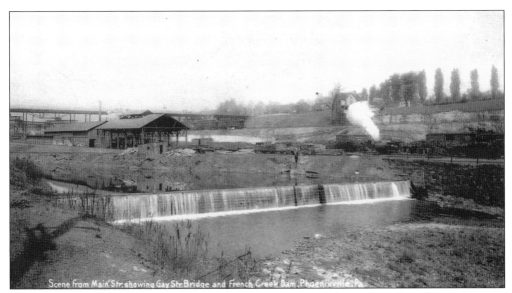

This postcard from 1910 shows the Gay Street Bridge, the French Creek Dam, and some Phoenix Iron Company buildings as viewed from Main Street. The old bridge that replaced this span in 1924 was torn down in 2008, the Phoenix Iron Company structures visible in this view were all torn down in the 1990s, and only remnants of the former dam remain today.

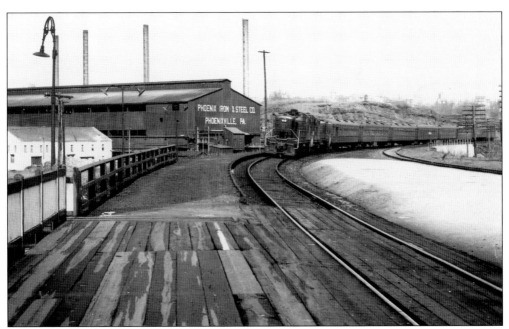

This image from the 1940s shows a train roaring past the Phoenix Iron and Steel Company on its way to the Philadelphia and Reading Railroad passenger station on east Bridge Street in Phoenixville. The station was a prominent passenger hub in its day but was made obsolete when passenger service in and out of Phoenixville began to dwindle. Today the Phoenix Iron and Steel building is gone, and the train station now houses a catering hall.

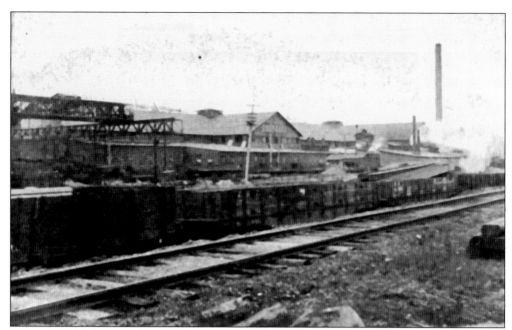

This early-20th-century view shows shop No. 6 of the Phoenix Iron Company. This structure was located just west of the Gay Street Bridge, behind the 300 block of Bridge Street. This entire structure was demolished in the late 1990s, and it has been decades since trains ran along French Creek as they did when this image was produced.

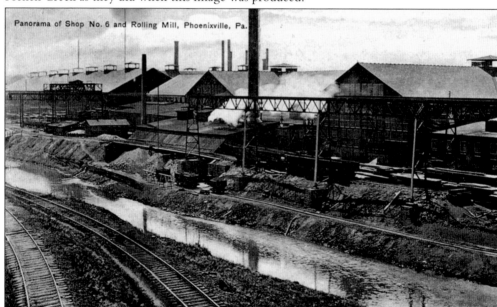

This postcard from 1908 shows a panorama of shop No. 6 and the rolling mill, located on the grounds of the Phoenix Iron Company. In this view, a set of train tracks runs parallel to French Creek, across from the huge structure. An intricate network of indoor cranes and mechanisms for moving steel once graced the underside of the massive building's ceiling. This entire structure was torn down in the late 1990s, and the property was still slated for redevelopment at the time of this writing.

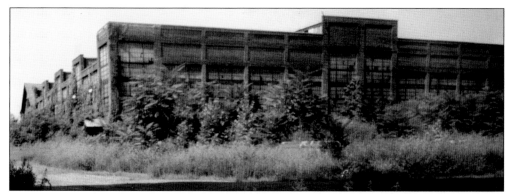

This view of the Phoenix Iron Company's shop No. 6 was taken toward the structure's last days. Years of neglect had left the building in a state of disrepair; vegetation had begun to overtake the interior and exterior of the structure, essentially sealing its fate. By the dawn of the 21st century, shop No. 6 would be just a memory. This photograph was taken from Main Street, looking west beyond the shadow cast by the Gay Street Bridge that loomed overhead.

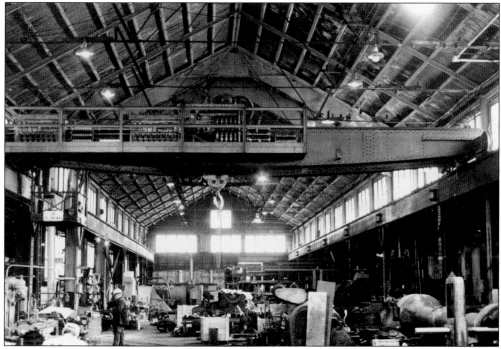

This interior view shows shop No. 1, located on the grounds of the former Phoenix Iron Company. By the time this image was produced, the Phoenix Steel Corporation had succeeded the former entity in operating the vast industrial complex. Shop No. 1 was alternatively known as the machine shop and was also the location for repair of small-gauge locomotives used by the company. (Courtesy of Donald Batzel.)

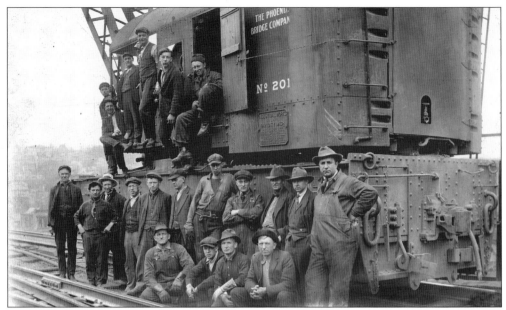

The Phoenix Bridge Company was located within the Phoenix Iron Company complex on east Bridge Street. This real-photo postcard from the 1920s shows a group of workers posing on and around one of the massive cranes used to move structural implements around the plant and at building sites. Phoenix bridges were world renown as marvelous feats of engineering, and the workers' prowess in constructing them was incomparable. Today the former Phoenix Iron Company site has been cleared and awaits redevelopment.

This image from 1988 shows the once mighty Phoenix Steel Corporation in the midst of being demolished. From this vantage point along the 100 block of Bridge Street, the shadow of the company's name adorns the upper portion of the building that has yet to be torn down. The brownstone building visible on the right of this photograph is the former superintendent's building. This is one of three buildings from the Phoenix Iron Company that remains today, and it has been completely restored and now functions as a restaurant.

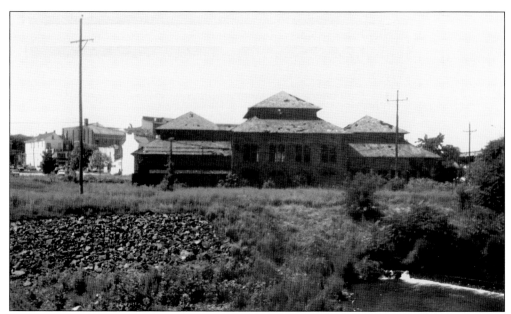

This photograph from 1997 shows the Phoenix Iron Company's foundry building in a state of ruinous decay as seen from the Main Street Bridge. In the ensuing years, this structure was rid of its industrial waste en route to a complete restoration. Today this building is one of Phoenixville's most iconic landmarks and hosts numerous special events from its location north of Mill Street.

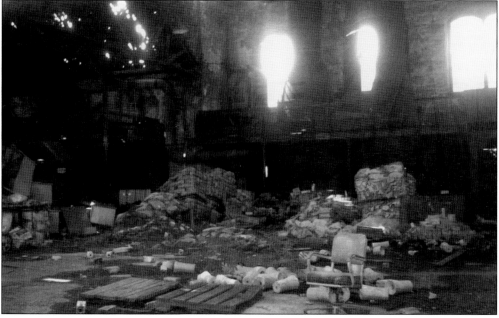

A photograph from 1994 shows the interior of the foundry building described above. With Phoenix Steel having ceased operations years before, the foundry and its contents had regrettably fallen victim to vandals and neglect. Today the waste left behind has long since been cleaned up, and the building has received a top-to-bottom restoration. It remains a centerpiece of attraction in Phoenixville's vibrant downtown.

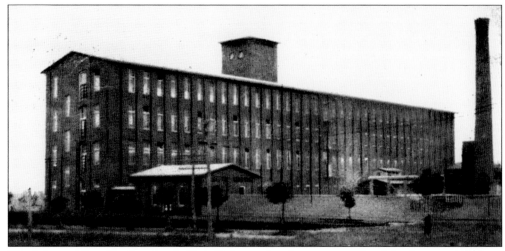

The Johnson-Cowdin Company silk mill, located at the corner of Franklin Avenue and Grant Street on Phoenixville's north side, is seen in this postcard from 1909. This building was added on to in the coming decades and would later function as the Budd Company. It is now home to an educational facility called Franklin Commons.

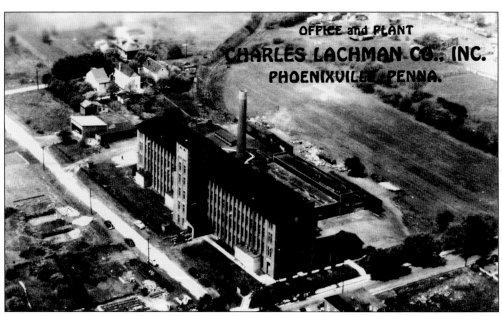

The Charles Lachman Company produced carpets and was located along Franklin Avenue at Grant Street on Phoenixville's north side. This aerial view postcard from the 1940s shows a large complex that would later be added on to in increments. Prior to housing the carpet company, this complex housed a silk mill. In later years, it would be home to the Budd Company. As of this writing, the complex had been redeveloped into an education center.

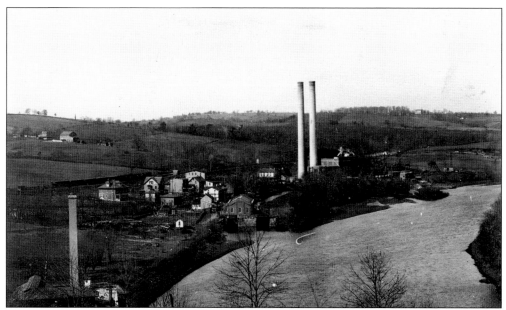

These images from 1905 show alternate views of the Cromby plant, located on Phoenixville's north side. Nestled along the Schuylkill River, the power station has been in operation for more than a century. At the top of the page, two giant smokestacks dominate the bucolic landscape around the complex. Although access to the station is restricted today, the plant was originally constructed in an open area near a residential neighborhood. Today many of the homes visible in this picture are still in existence along Cromby Road, near Water Street. Incidentally, the larger structure toward the lower left of the image was known as the Phoenixville Water Power Company. It too still operates today at its location along Water Street. The Cromby Generating Station, as it is known today, is one of the region's leading producers of energy.

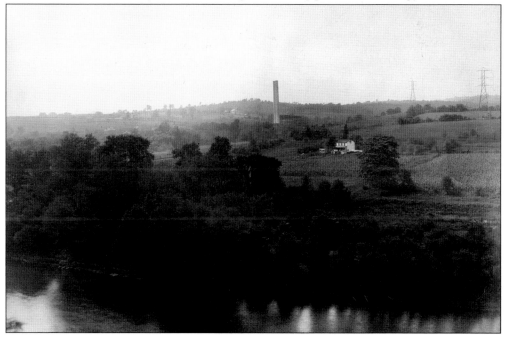

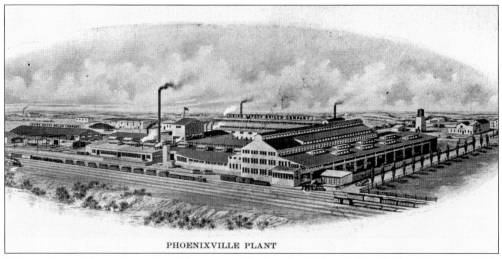

PHOENIXVILLE PLANT

This trade card from the early 20th century depicts the Heine Safety Boiler Company. This complex was located off Second Avenue near Manavon Street and has seen significant alteration over the years as new industrial tenants occupied the space. The Heine Safety Boiler Company was headquartered in St. Louis, Missouri, but the Phoenixville plant was integral to the company's longevity and success.

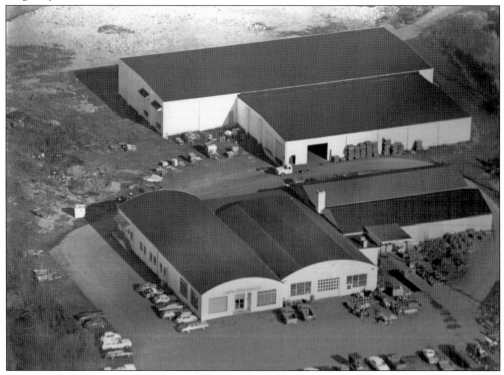

This early-1970s aerial view shows the Lawn and Golf Supply Company located along Nutt Road, just beyond Paradise Street. The company was founded more than six decades ago and has sold various types of lawn mowers and related equipment over the years. This operation continues in business as one of Phoenixville's most enduring commercial establishments. (Courtesy of the Lawn and Golf Supply Company.)

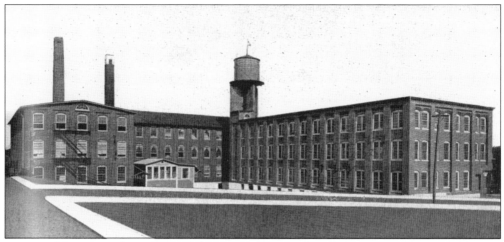

A postcard from 1909 shows the Byrne knitting mill, located along Morgan Street between Lincoln Avenue and Buchanan Street. Although the building is still in use today, it has been preserved through conversion to residential condominiums. The original structure remains largely intact, with the exception of the wooden water tank, which was removed in the late 20th century.

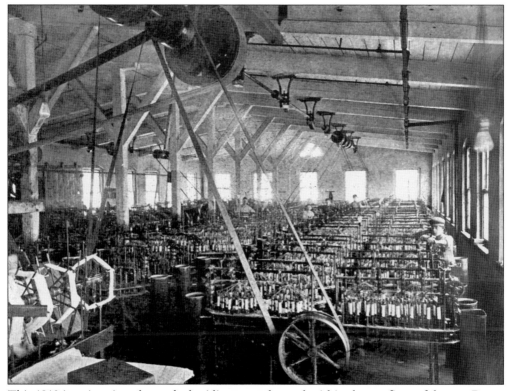

This 1910 interior view shows the braiding room located within the confines of the vast Byrne knitting mill. Several workers pause for a break as the space is photographed. The Byrne knitting mill had the capacity to produce thousands of undergarments, shoelaces, and related items every day.

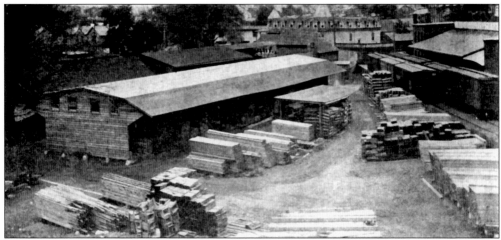

The Frank C. Andrews and Company Lumber and Coal firm was located along Bridge Street as seen in these views from 1914. The company thrived as a supplier of building materials at a time when Phoenixville was experiencing steady residential growth. In the image above, the rear of the Hotel Chester is visible at the center of the view. The image below shows the front entrance, along with two trucks poised to deliver their loads. The door of the delivery truck features the business name and a three-digit telephone number. This business and the array of buildings that comprised it are but a distant memory today.

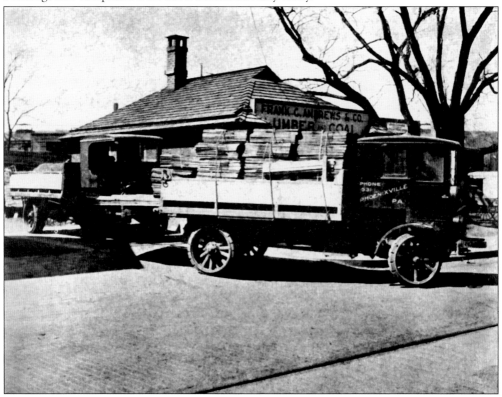

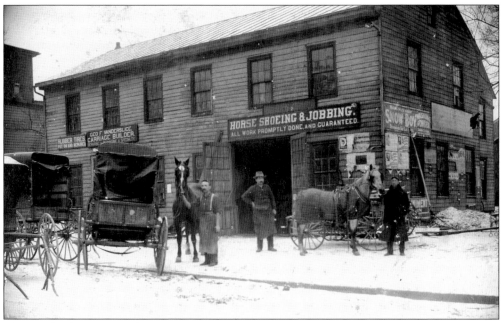

The Vanderslice carriage shop is seen in this early-20th-century view. In addition to the multitude of advertisements that adorned the side of the building, signage above the entrance indicates "horse shoeing & jobbing" along with "all work promptly done and guaranteed." This structure was located along Church Street, just off Bridge Street near the Hotel Chester.

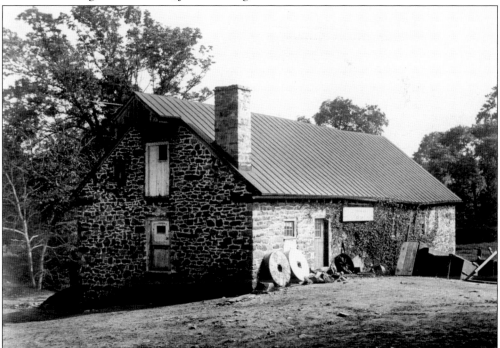

This real-photo postcard from 1901 shows the Pennypacker mill that was located along Pickering Creek at William's Corner, near the intersection of Pothouse and Whitehorse Roads. The sign on the building reads, "J.C. Pennypacker Grain & Feed." The mill was torn down decades ago.

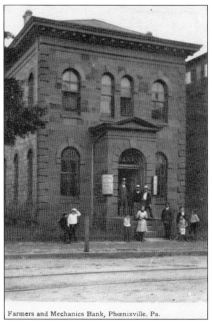

The Farmers and Mechanics National Bank, founded in the late 19th century, is seen in this postcard from 1906. This building stood at the southeast corner of Main and Church Streets until it was replaced by the current structure in 1925. Through various mergers and acquisitions, it has continued to function as a banking institution for more than a century.

Farmers and Mechanics Bank, Phœnixville, Pa.

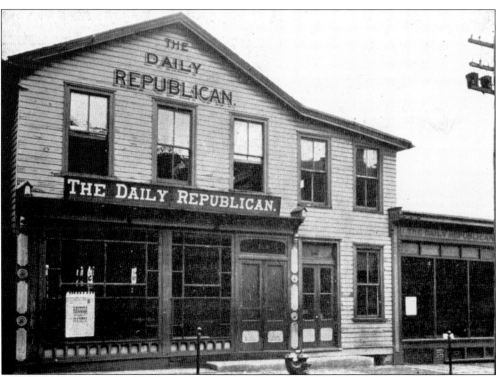

The Daily Republican had its newspaper office in this building located along east Bridge Street as seen in this image from 1915. Although the Daily Republican nameplate ceased to exist decades ago, the newspaper continues its legacy under the moniker the *Phoenix*. The building was torn down long ago, as the Daily Republican moved one block up Bridge Street and into the former National Bank of Phoenixville building.

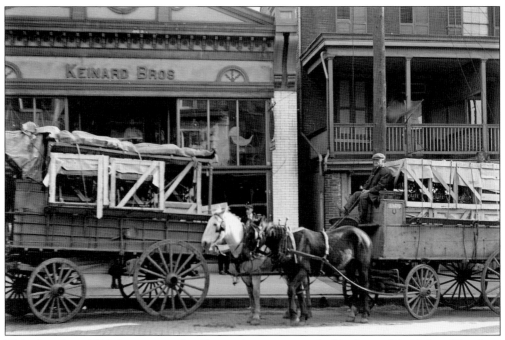

This view from 1909 shows a couple of horse-drawn carts parked in front of the Keinard Brothers store located at 248 Bridge Street. Next to the store is a residential structure that featured a street-level storefront. Today a restaurant occupies the former Keinard Brothers store.

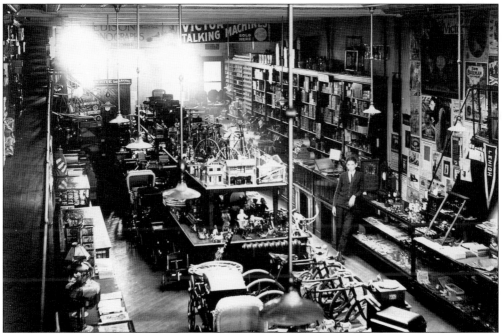

As is evident in this image from 1909, the interior of the Keinard Brothers store was stocked with a variety of housewares, bicycles, baby coaches, and other items. One of the most prominent features in the photograph is a sign hanging toward the front of the store that advertises "Victor Talking Machines."

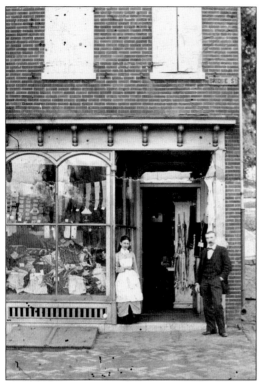

A couple is seen standing in front of their store at 128 Bridge Street in the early 20th century. The building, located at the corner of Bridge Street and Church Alley, has been gone for decades. At the time of this view, the store appears to carry a variety of items, as evidenced by the display of wares in the large front window. Phoenixville's business district thrived for decades before taking an economic downturn in the 1980s upon the closing of the Phoenix Steel Corporation. In recent years, revitalization efforts have taken hold and the downtown is once again bustling with commerce.

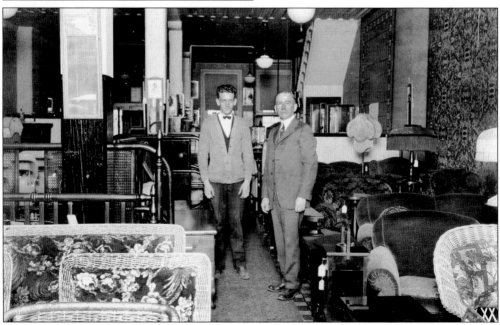

This pre–World War II interior view shows a furniture store operating at 207–209 Bridge Street in the building that would spend the latter part of the 20th century as Whitey's Hardware. This massive structure is easily one of the largest retail spaces on Bridge Street and is located a few storefronts east of Bank Street. Subsequent to the closure of Whitey's, this building was subject to extensive renovation and operates today as an arts center. (Courtesy of Joan Benne.)

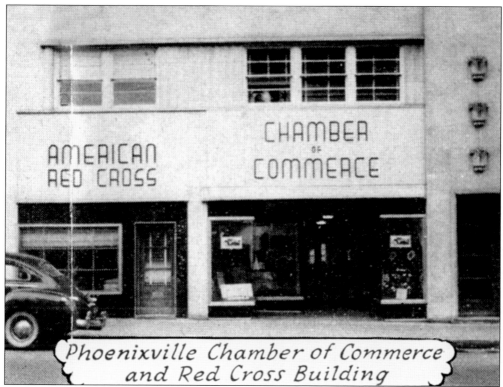

Phoenixville Chamber of Commerce and Red Cross Building

This World War II–era view shows a couple of storefronts in the 100 block of Bridge Street. The local chapter of the Red Cross had an office in downtown Phoenixville at the time, and the Phoenixville Chamber of Commerce was its immediate neighbor. Today the building houses a music store, and the Phoenixville Chamber of Commerce has moved to its present location adjacent to its former space.

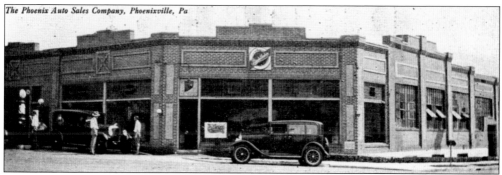

The Phoenix Auto Sales Company is seen at the intersection of Nutt Road and West Bridge Street in this view from 1930. Since the building's inception, it has been used for automotive sales and service under various owners. The brick facade seen in this image was covered long ago when the building was renovated and modernized. Despite several expansions over the years, the unique design of the building is evident to this day.

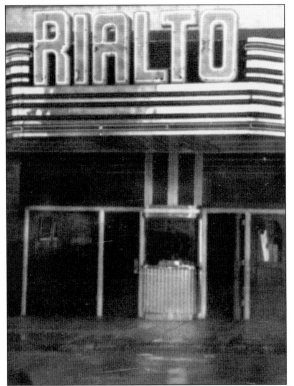

This 1940s view shows the front entrance of the Rialto movie theater, located along Main Street between Hall and Walnut Streets. The theater was one of three in Phoenixville at the time, in addition to the Savoy farther north on Main Street and the surviving Colonial on Bridge Street. The Rialto was torn down decades ago and replaced with a YMCA. By the 1980s, the YMCA was demolished. Today the property is home to a bank.

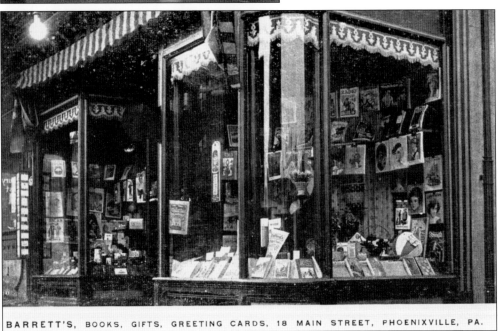

BARRETT'S, BOOKS, GIFTS, GREETING CARDS, 18 MAIN STREET, PHOENIXVILLE, PA.

This postcard from 1907 shows the window display at Barrett's, a business that specialized in books, gifts, and greeting cards. Barrett's was located at 18 Main Street, just off Prospect Street in Phoenixville's downtown business district. Although the storefront remains today, Barrett's is but a distant memory.

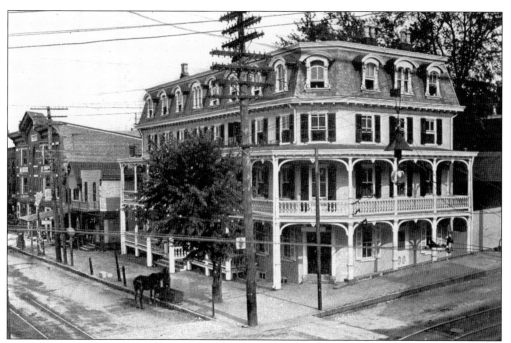

The four-story Phoenix Hotel stood at the southeast corner of Bridge and Main Streets and is seen in this view from 1909. The hotel's central location made it one of Phoenixville's most prominent meeting places. With progress on the horizon, the building was torn down in 1949. In its place rose W. T. Grant's, a variety store. Today the variety store is also gone and the site is now a municipal parking lot. In this view, the former Wall Block Inn can be seen to the left of the hotel. That structure was destroyed in a devastating late-1980s fire.

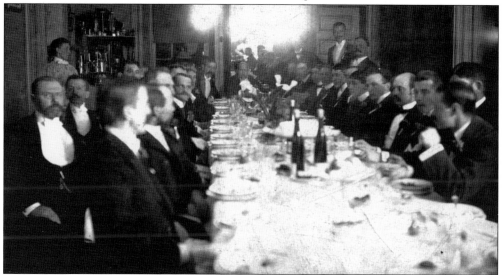

A group of formally attired gentlemen has gathered in the dining room of the Phoenix Hotel in this view from 1901. In addition to the lavishly set table, another luxury was present at this dinner party, and that is an electric fixture providing light for the event. The Phoenix Hotel was one of the largest and most centrally located venues for such events, and it hosted numerous dinners and parties until it was torn down in the late 1940s.

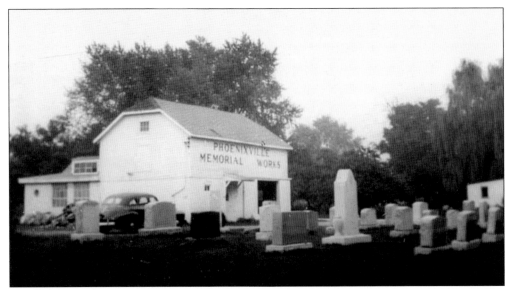

The Phoenixville Memorial Works is seen in this real photograph from the 1940s. Located along Nutt Road, just west of Whitehorse Road, the business is still in operation today. Although original elements of the old barn still exist, a new addition to the front of the structure has made the facade almost unrecognizable these days. (Courtesy of Mrs. S. Martin Hamman.)

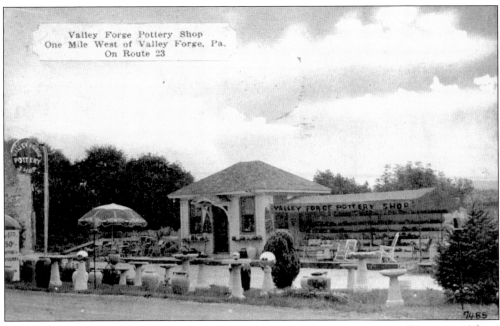

The Valley Forge Pottery Shop was located in Schuylkill Township as seen in this postcard from the 1930s. The roadside stand sat along Route 23, between Phoenixville and Valley Forge. Today this stretch of road has a predominantly residential character to it and is a busy thoroughfare between Chester and Montgomery Counties. Little is known about the history of this bygone landmark, as no structural evidence of it remains.

The Bull Tavern is seen in this postcard from the 1950s in its location along Route 23 near Pawlings Road. The original structure was built in 1734 and functioned for the next two and a half centuries in its original intended capacity. Banquets, dinners, and drinks were served in its many rooms in a continental atmosphere reminiscent of the late 18th century. The interior view seen below shows the bar and lounge as it appeared in the late 1950s. Today the building houses a few different businesses yet maintains much of its original exterior structure despite the Bull Tavern's official closure in the late 1980s.

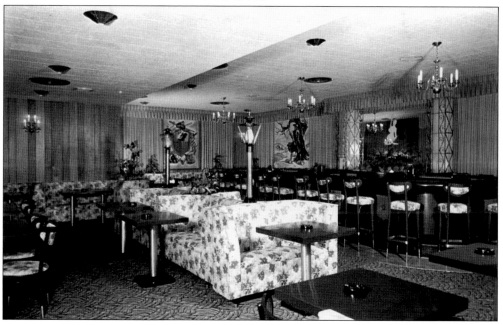

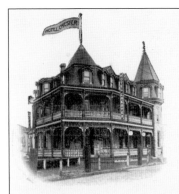

HOTEL CHESTER

John H. Babb, Prop.

Phoenixville, Pa.

Commercial Trade Solicited

The Hotel Chester is seen in this view from 1915 and is still located along Bridge Street at Church Street in Phoenixville. This old trade card indicates that "commercial trade" is solicited. Today the building no longer functions as a hotel but primarily as an apartment house. In 2009, a saloon occupies the old bar space, and many architectural elements original to the building remain in place.

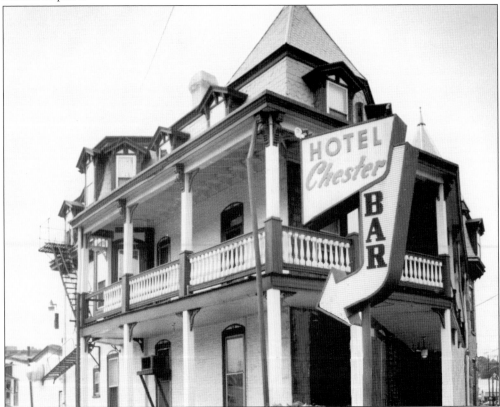

More than 50 years have elapsed since the image above was produced, yet the Hotel Chester is still recognizable. One addition to the building's character was the 1950s sign pointing prospective customers toward the bar entrance. The Hotel Chester remains one of Phoenixville's most prominent landmarks and an example of responsible preservation of the past.

This 1994 photograph shows the General Pike Hotel, located at the intersection of Routes 23 and 113 in Phoenixville. The hotel was an early-19th-century stop on the pony express mail service route. Operating primarily as a bar in its final days, the structure was torn down despite protests trumpeting its historical value. Almost 15 years later, the former hotel site has been redeveloped as a chain pharmacy.

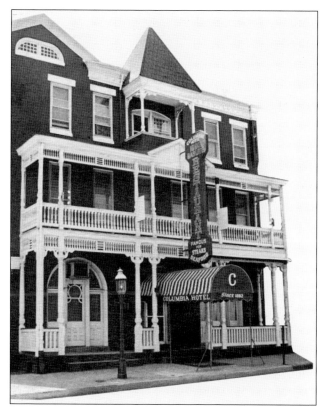

The Columbia Hotel is seen in this postcard from the 1970s in its location at 148 Bridge Street. The building has served Phoenixville as a hotel, restaurant, and bar for more than 100 years almost without interruption. The hanging sign advertising an "1890s gaslite" experience was removed long ago, and the building has since undergone a complete renovation that modernized its facilities but carefully maintained much of its original character.

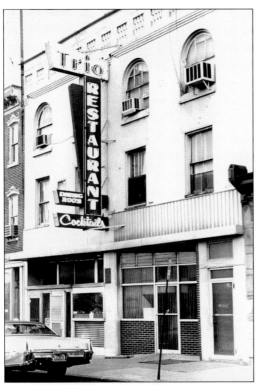

This view from the 1970s shows the Trio Restaurant located at 178–180 Bridge Street. The restaurant began life in the 1940s and enjoyed decades of success before finally closing in the mid-1980s. Although the hanging sign that advertised its dining room and cocktails was removed commensurate with the restaurant's closure, the building remains today and is easily recognizable. (Courtesy of Paul Mastrangelo Jr.)

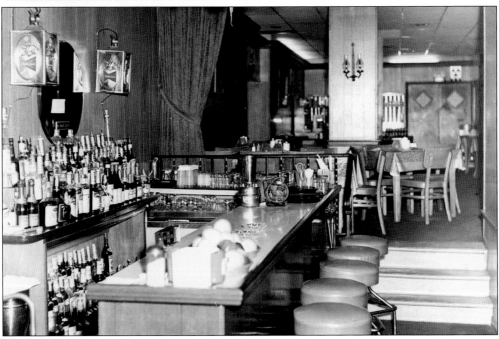

This image shows a portion of the dining room and well-stocked bar at the Trio Restaurant. Although the enterprise was initially conceived in the 1940s as an Italian restaurant, the concept evolved over the coming years. For decades, the Trio served good food at reasonable prices for many Phoenixville residents and visitors alike. (Courtesy of Paul Mastrangelo Jr.)

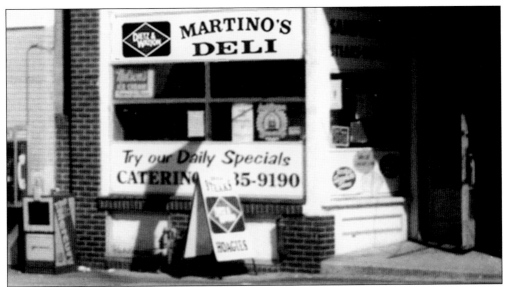

This postcard from the early 1990s shows Martino's Deli, located at 323 Bridge Street in downtown Phoenixville. The author's mother operated a delicatessen and catering establishment at this location for several years before closing in 1998. The small store commanded a brisk lunchtime business, catering to businesspeople and residents alike. In 2009, the building sits idle despite high occupancy in Phoenixville's retail district.

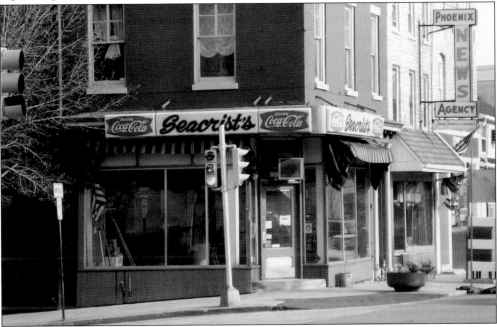

This photograph from late 2005 shows Seacrist's and the Phoenix News Agency, a Phoenixville institution for decades. Residents would gather around the counter on a daily basis to discuss news, sports, and life in town. Today the former dual-storefront business has been converted to a bar and restaurant. A diligent exterior renovation managed to retain much of the historic building's original character, but an overhaul of the interior leaves that attribute of the building virtually unrecognizable today.

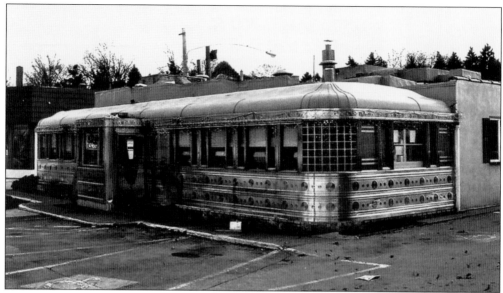

The Vale-Rio Diner was located along Nutt Road at West Bridge Street since its construction in 1948. The diner was one of the last in the region and served up consistent food and atmosphere for more than six decades. Residents and visitors alike could always count on the 24-hour illumination and welcoming spirit provided by the diner. The image below captures the diner preparing to be moved east on Nutt Road to a lot located at the intersection with Starr Street, where it has been stored since March 2008. The diner's ultimate fate appears uncertain.

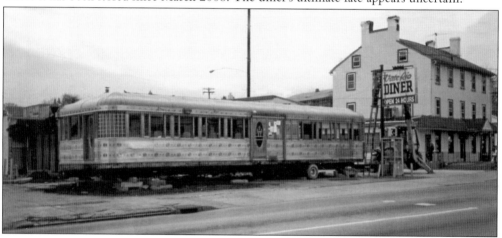

Three

COMMUNITY
INSTITUTIONS

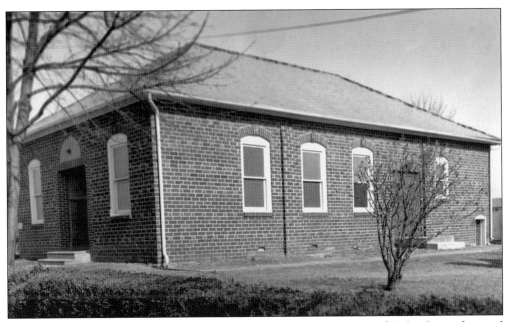

This view from the 1950s shows the modest clubhouse of the Knights of Columbus, a fraternal organization located along Fairview Street at Rhoades Street on Phoenixville's north side. The club sits adjacent to the SS. Peter and Paul Ukrainian Catholic Church that was constructed in 1929. The Phoenixville council of the Knights of Columbus was formed in 1909 and celebrates its 100th anniversary in 2009. Membership in the organization is limited to Catholic men, aged 18 and older, who are committed to the church and the betterment of their communities.

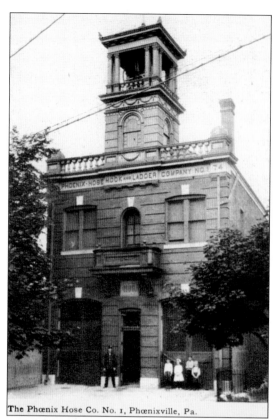

In this postcard from 1910, the Phoenix Hose, Hook and Ladder Company No. 1 can be seen in its location along Church Street, between Main and Jackson Streets. The engine house shown here was completed in 1901 and would retain much of its original structure until a more modern facility was constructed in the 1970s.

The Phœnix Hose Co. No. 1, Phœnixville, Pa.

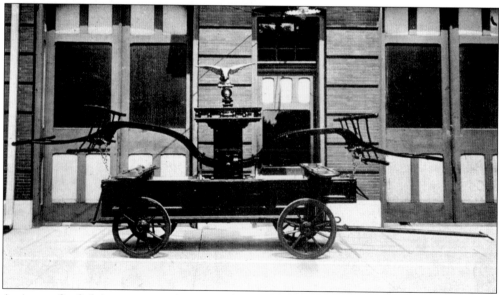

A vintage firefighting apparatus is seen in this real-photo postcard from 1908 sitting in front of the Phoenix Hose, Hook and Ladder Company No. 1. The narrow doors in the background were clearly designed for horse-drawn firefighting equipment to enter and be stored. Decades later, the facility had outgrown its practicality and was replaced by a modern structure that still stands today.

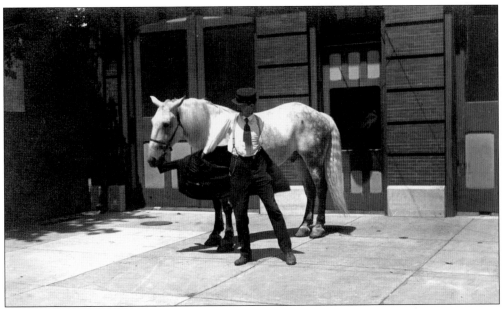

One of the horses integral to the successful operation of the Phoenix Hose, Hook and Ladder Company No. 1 is seen in this real-photo postcard from the early 20th century. In this view, its trainer is attempting some sort of maneuver in front of the firehouse on Church Street.

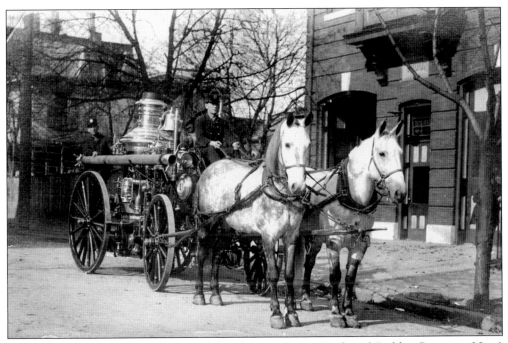

A team of horses is shown in front of the Phoenix Hose, Hook and Ladder Company No. 1 along Church Street, just east of Main Street in this postcard from the early 20th century. As a precursor to mechanized fire engines, these horses pulled the vintage firefighting implements all around town. This fire company is one of three that has served Phoenixville for generations.

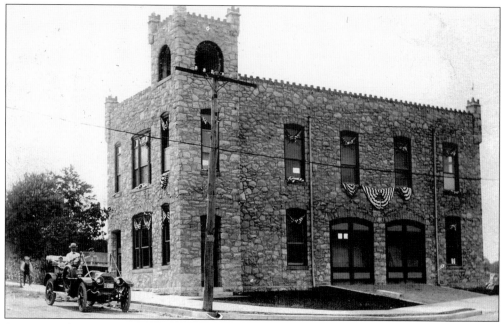

A postcard from 1910 shows the West End Fire Company located along West Bridge Street at Pennsylvania Avenue. This imposing stone structure has been added on to over the years but is still easily recognizable and continues to serve the community in its original, intended capacity.

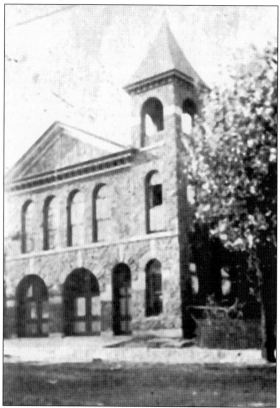

An early-20th-century postcard shows the Friendship Fire Company located along High Street, west of Franklin Avenue on Phoenixville's north side. Although the bell tower was deemed obsolete long ago and enclosed, it still remains part of the structure. The firehouse retains much of its original architectural character despite numerous interior and exterior modifications over the years.

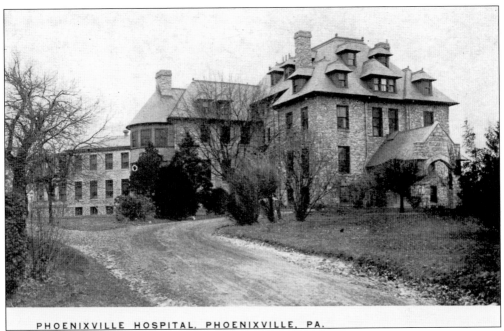

PHOENIXVILLE HOSPITAL, PHOENIXVILLE, PA.

This 1910 postcard shows the Phoenixville Hospital located along Nutt Road between Main Street and Gay Street. This building and subsequent additions stood well into the 1960s when the current facility was completed. Today the east end of the Phoenixville Hospital complex occupies the site of the original building.

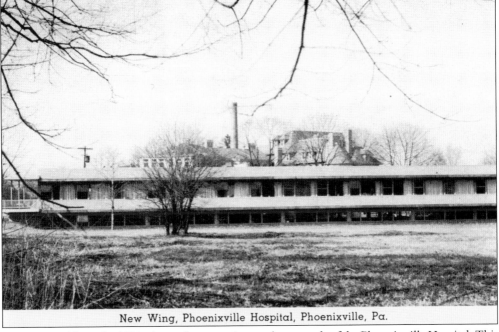

New Wing, Phoenixville Hospital, Phoenixville, Pa.

This postcard from the 1950s shows the new wing on the grounds of the Phoenixville Hospital. This wing was located near Main Street, just south of Nutt Road. As the main hospital building grew, the wing pictured here became obsolete by the late 1980s and was subsequently torn down.

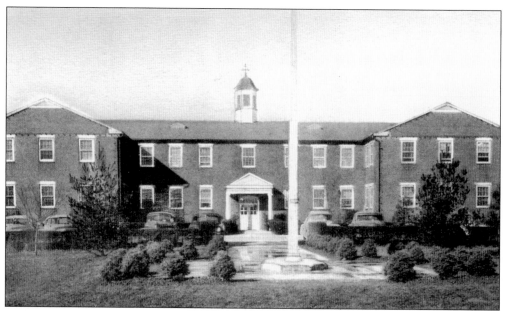

The building in this 1950s postcard served the Valley Forge General Hospital in an administrative capacity for decades. Today it is one of the most prominent buildings on the campus of the Valley Forge Christian College. Despite the growth and progress experienced by the school over the last couple decades, this structure retains much of its original exterior character. This building can be seen from the Charlestown Road entrance to the campus.

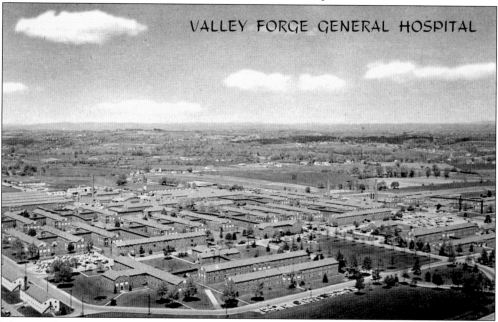

This aerial view postcard of the Valley Forge General Hospital was taken in the 1950s. The site comprised numerous buildings that housed living quarters, medical facilities, and areas for recreation. Many of the structures were connected via a labyrinth-like network of subterranean tunnels. Although a lot of these buildings fell into disrepair and were demolished after having been vacated by the military, many survive today and were adapted for reuse as a college.

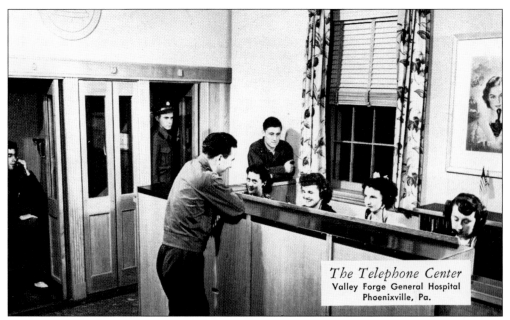

The Telephone Center
Valley Forge General Hospital
Phoenixville, Pa.

These postcards from the 1950s depict the telephone center located at the Valley Forge General Hospital. The hospital complex was constructed during World War II and stayed in service through the close of the Vietnam War. These views show servicemen utilizing the facilities to contact friends and family spread out across the United States. In the image below, a sign on the wall notes that booths No. 5–8 (shown) were in service at "all hours." In addition to the telephone center, the sprawling complex included a movie theater, bowling alley, and golf course.

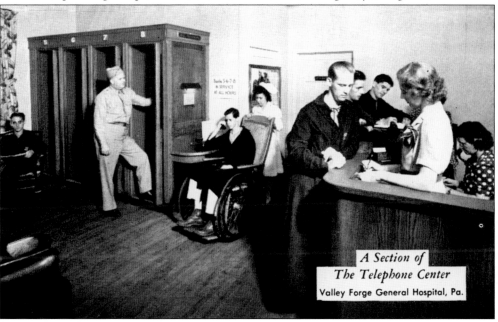

A Section of
The Telephone Center
Valley Forge General Hospital, Pa.

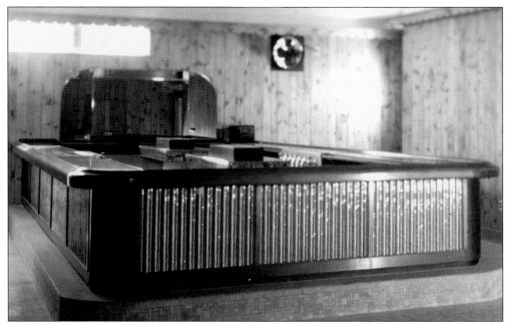

This late-1940s interior view shows the bar at the St. Anna Italian Club located along Dayton Street on Phoenixville's north side. At one time, Phoenixville boasted several clubs of ethnic affiliation, including separate Hungarian, Slovak, Ukrainian, and Polish clubs. The St. Anna Italian Club underwent extensive renovations in the 1990s.

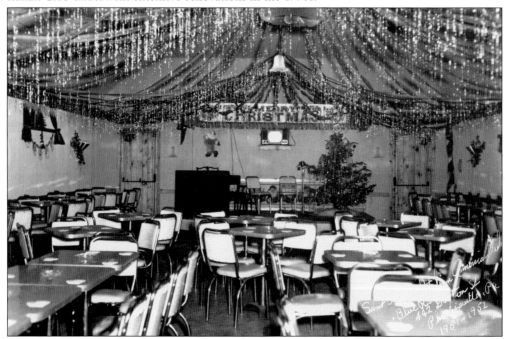

This image from the early 1950s shows the interior of the St. Anna Italian Club decorated for Christmas celebrations. In addition to a small stage with a piano and microphone, a vintage television was mounted at the center of the room. Today the Italian club remains a vibrant fraternal organization in Phoenixville.

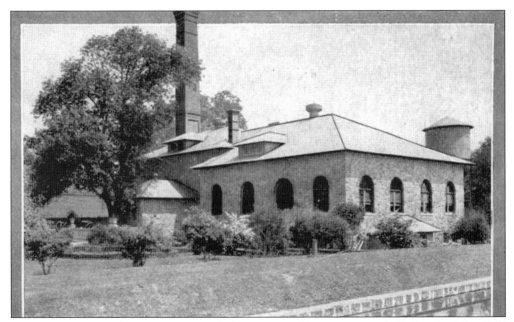

The Pickering Creek station is located along Route 23, near Moorehall dam in Schuylkill Township. However, the current buildings that house the water station are far more modern than the one seen in this card from the 1930s. The station continues to provide water for a burgeoning population in Phoenixville and neighboring townships.

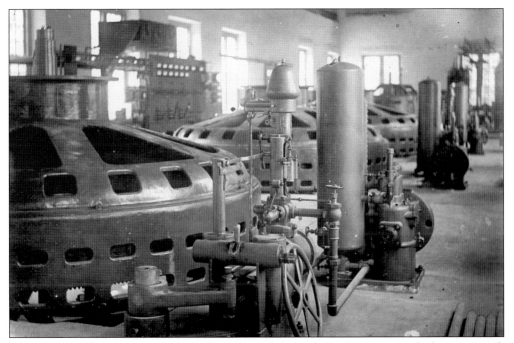

The Phoenixville Water Power Company is seen in this early-20th-century real-photo postcard. The water plant is located aptly enough along Water Street on Phoenixville's north side, just off Cromby Road. With certainty, the equipment supporting the contemporary water supply is more modern than the apparatus visible in this view.

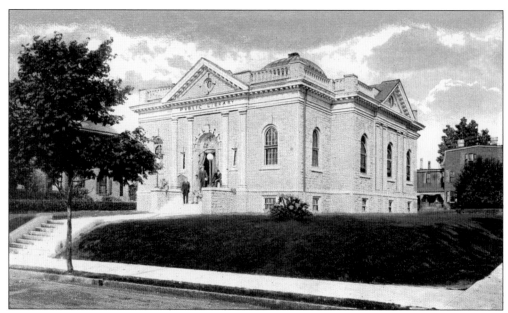

The Phoenixville Public Library appears in this postcard from 1905. Although more than a century has passed, the library's main building appears much as it did when built in 1901 thanks to a grant by wealthy tycoon Andrew Carnegie. The rooftop dome was removed long ago, and a 1987 renovation and addition updated the library and its capacity. It continues to serve the community at the corner of Main Street and Second Avenue.

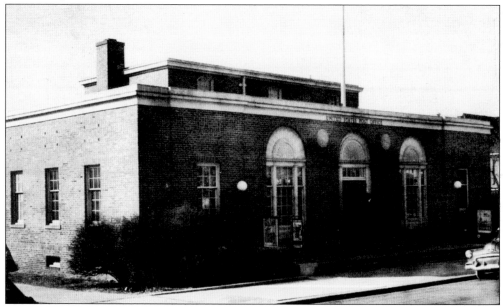

The post office is seen in this early-1950s postcard. Located on Gay Street at Church Street, this facility was built to accommodate the needs of Phoenixville's fast-growing community. Although the building has received several interior modifications over the years, the front of the edifice remains much the same today, save for the addition of an access ramp. Years ago, acquisition of some neighboring homes allowed the post office to expand and create additional parking at the site.

Four

RESIDENTIAL VIEWS

This residential view is taken from a real-photo postcard that bore a Phoenixville postmark from the year 1910. In this image, two unidentified gentlemen relax in rocking chairs on the front porch of a home located at 155 Washington Avenue, between Jackson and Main Streets. Today this pair of homes has been subdivided into apartments, yet much of the original exterior character remains intact. The distinctive pattern visible on the wooden front door is still evident today, as are the uniquely planed wood dowels that separate the two front porches.

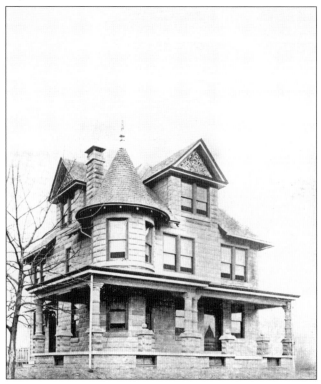

These grand residences are seen in views from 1920. Located along Second Avenue between Lincoln Avenue and Quick Street, these houses remain in existence, benefiting from solid construction and consistent maintenance. The primary building materials used to construct the homes were called keystones. Today these houses face Samuel K. Barkley Elementary School, which would have been an empty field at the time of their construction. Despite being such large homes, they have small backyards given the row of homes built immediately behind them on Grover Street.

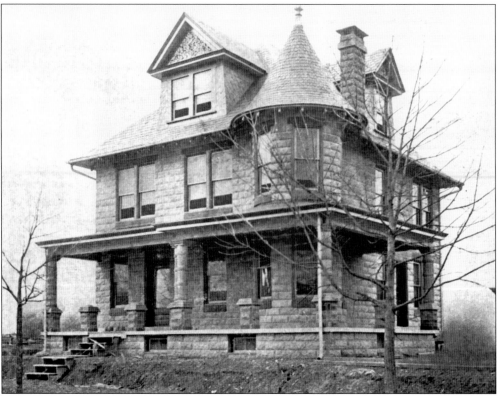

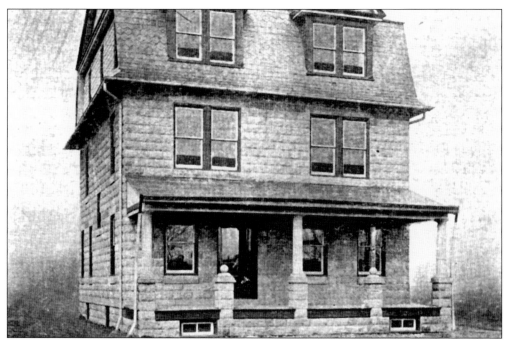

This large home was constructed at the same time as those described on the preceding page and made of the same material called keystone. Also located along the 300 block of Second Avenue, these iconic homes represent the eclectic design of many of Phoenixville's older residences.

This 1925 view shows a home on Main Street, north of Nutt Road, as it appeared shortly after construction. Beyond having functioned as a residence for many decades, this structure has also served numerous commercial purposes. Despite its multiuse over the years, the home is easily recognizable today.

The home seen here is located at the northwest corner of Second Avenue and Buttonwood Street in Phoenixville. These real-photo postcards from the early 1920s show the family car proudly displayed in front of the residence and then about to enter the garage on Buttonwood Street. This building has managed to retain much of its original exterior appearance despite the more than 80 years that have elapsed since these images were produced. Although the residence would eventually be converted to a funeral home, and subsequently an art gallery, it has been subject to recent renovation that has restored its primary residential character. Incidentally, the background of the image below reveals a set of homes located along First Avenue.

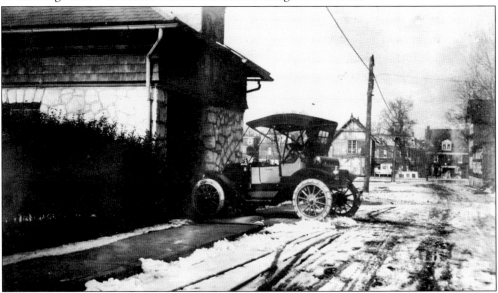

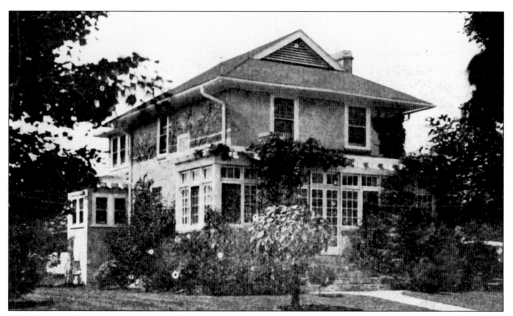

This home is located at 240 Griffen Street, between Gay and Main Streets. The image from the early 1920s reveals a home with mature landscaping and a meticulously tended lawn. Phoenixville spent much of the 20th century developing a unique residential character, and it could never be categorized as a town of cookie-cutter homes thanks to the architectural splendor and vision evident in the many beautiful houses seen around town.

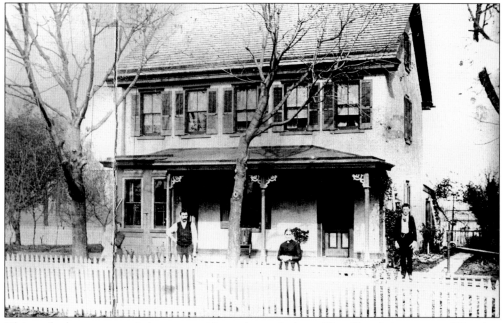

This real-photo postcard shows a residence located along Nutt Road, just west of Rossiter Avenue. This early-20th-century view shows a family standing in the front yard of its home that would have been located in a very rural area at the time. Years later, the stucco was removed, revealing the original stone construction of the house. The residence still remains functional and occupied.

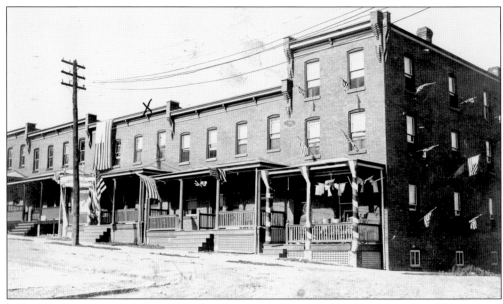

This real-photo postcard from 1910 shows a group of row houses located on Franklin Avenue between High and Vanderslice Streets. The homes were festooned with patriotic decorations as part of Phoenixville's homecoming celebration. These residences still exist today, and the exteriors have received only minor modifications during the last century, leaving them quite recognizable.

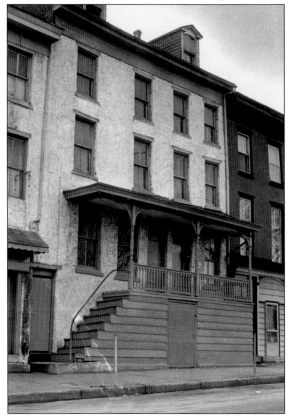

This view from the 1960s shows a pair of residences sitting in the heart of the 100 block of east Bridge Street's residential district. These structures were divided into apartments sometime during their lives and were ultimately torn down in the late 1980s. Today a condominium with a ground-floor restaurant has risen in their place.

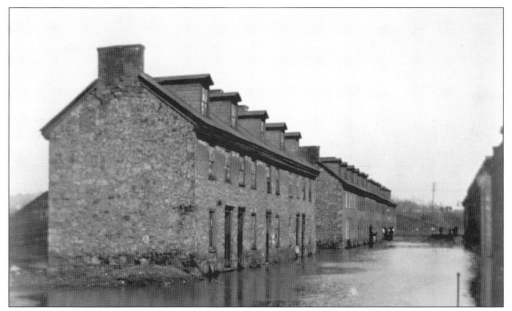

This view from 1902 shows an area known locally as Puddler's Row. These homes were once located adjacent to the Phoenix Iron Company property on the northern side of east Bridge Street. Prone to frequent flooding, the old stone homes were eventually demolished. At one time, the most common vantage point for one to have viewed this scene would have been from the rear of the Mansion House restaurant.

This home was once located at the intersection of Route 23 and Whitehorse Road in an area known as Corner Stores, so named for the fact that each of the four corners comprising this intersection once featured commercial enterprises. The structure was located on the southeast corner of the intersection and is a memory of the distant past today.

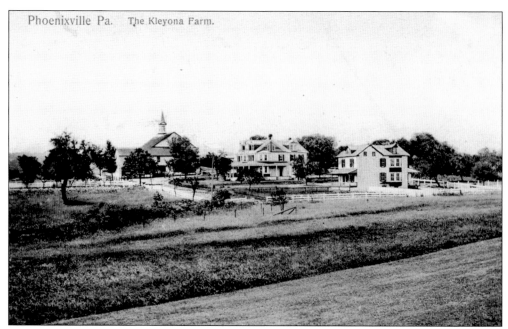

Phoenixville Pa. The Kleyona Farm.

A postcard from 1912 shows the Kleyona Farm, one of many large farms to be found in Phoenixville during the early 20th century. With the passage of time, many such estates have been developed with housing or commercial interests in mind. The Kleyona Farm fell victim to this same fate, but the general area retains its identity in the form of Kleyona Avenue.

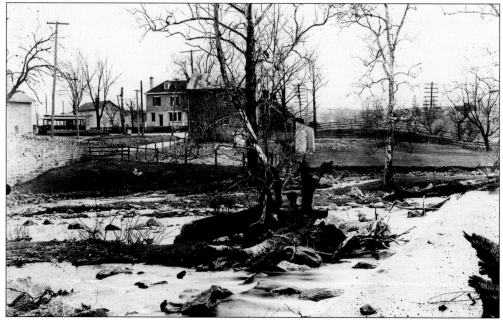

This view shows an area in Schuylkill Township known as William's Corner as it was in 1916. Looking south on Whitehorse Road, near Creek Road, this is a glimpse of the old covered bridge that spanned Pickering Creek. The bridge was replaced in 1927, and all the structures seen in this view were torn down long ago. An old trolley car idles along Valley Park Road in an area that is now home to the Schuylkill Township administration building.

Five

BRIDGES AND RAILROADS

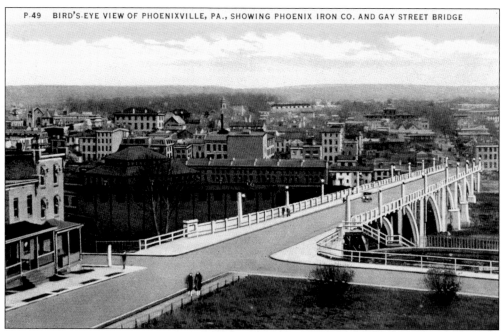

P-49 BIRD'S-EYE VIEW OF PHOENIXVILLE, PA., SHOWING PHOENIX IRON CO. AND GAY STREET BRIDGE

This postcard from the 1940s depicts a bird's-eye view of Phoenixville showing the Phoenix Iron Company and Gay Street Bridge. This unique image encompasses not only the expansive iron company grounds but also much of Phoenixville's World War II–era skyline. This view looks south from the intersection of Franklin Avenue and Vanderslice Street on Phoenixville's north side. Just beyond the roof of the foundry building, several mid-19th-century homes along Mill Street are clearly visible. The Gay Street Bridge shown in this image was constructed in 1924 and torn down in 2008. The grass lot visible in the foreground is occupied by a row of mid-20th-century houses. However, the general vista that looks toward the downtown is largely intact to this day.

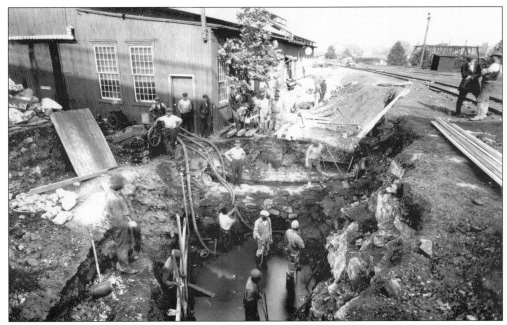

This real-photo postcard from 1922 shows several workers toiling in and around a ditch that was integral to the construction of the Gay Street Bridge. One of the Phoenix Iron Company's buildings is visible in the background, as the bridge spanned the property. Additionally, a small Phoenix Bridge Company bridge is visible to the right in the image. This bridge still crosses French Creek today near the foundry building on Main Street.

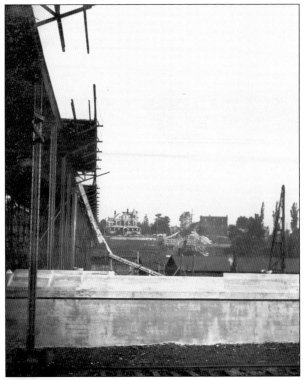

This real-photo postcard from 1923 shows the construction of the Gay Street Bridge, which is progressing well. This view looks toward the north side of Phoenixville. The large house located in the distance still stands at the corner of Vanderslice Street and Kurtz Lane. The strip of row homes also visible in the background remains in place today along Franklin Avenue between High and Vanderslice Streets.

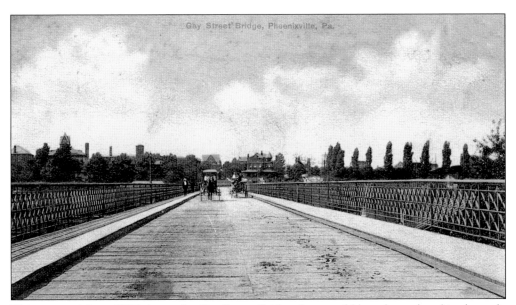

This postcard from 1907 shows the Gay Street Bridge that would later be replaced in the early 1920s. In this view that looks to the north side, a pair of horse-drawn carriages crosses the bridge in opposite directions. The surface of the bridge was made of wooden planks, and the sides were adorned with ornate metal rails. As automobiles replaced horse-drawn carriages as the principal mode of transportation in Phoenixville, a new bridge was warranted, and the one seen in this postcard was torn down in 1922.

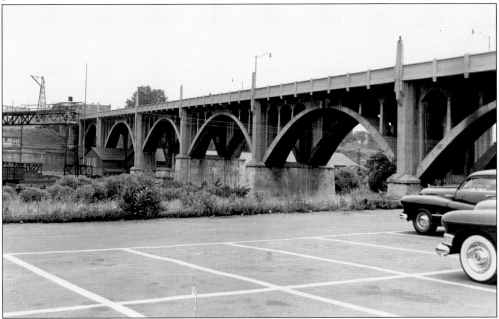

This view from the early 1950s shows the Gay Street Bridge almost three decades after its construction. The bridge opened in 1924 and lasted more than eight decades before being torn down. In 2009, a new span began rising in its place. The Phoenix Steel Corporation buildings and infrastructure that once existed under the trusses of the bridge were demolished long ago. The tract of land now sits idle awaiting redevelopment.

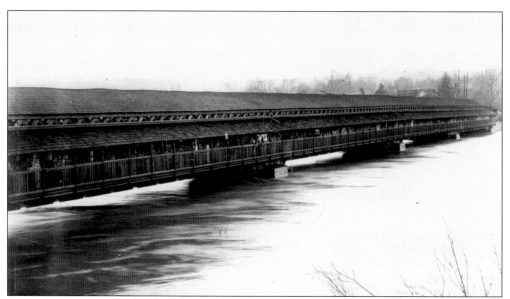

These real-photo postcards from 1902 show the intercounty covered bridge that carried travelers between Chester and Montgomery Counties. The view above was taken from the Phoenixville side of the Schuylkill River. The river had clearly swollen to an elevated level that spring, as the waterline is just beneath the surface of the bridge. The view below shows the entrance to the same bridge also seen from the Phoenixville side of the river. In this image, the bridge tender's house is visible; this once sat just down the hill from the Philadelphia and Reading Railroad passenger station and was torn down long ago.

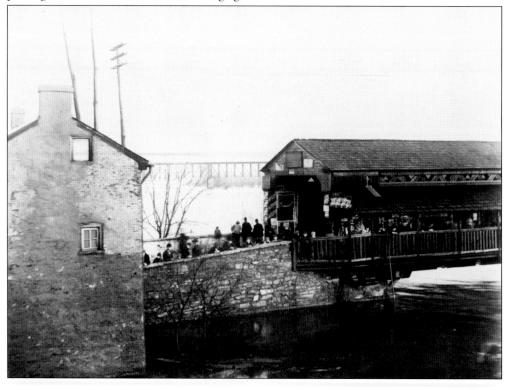

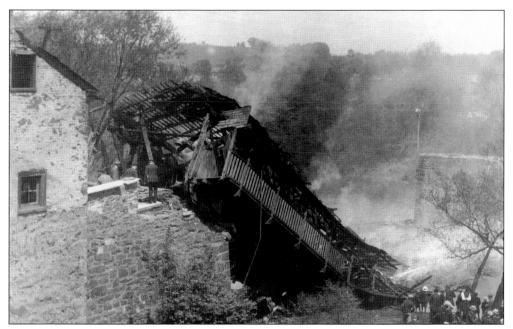

A devastating fire destroyed the intercounty covered bridge in 1915. In this view taken from the Phoenixville side of the river, the bridge tender's house can be seen near the collapsed ruins of the old covered bridge. Several residents have turned out to examine the catastrophic scene surrounding the still-smoldering remnants of the wooden bridge.

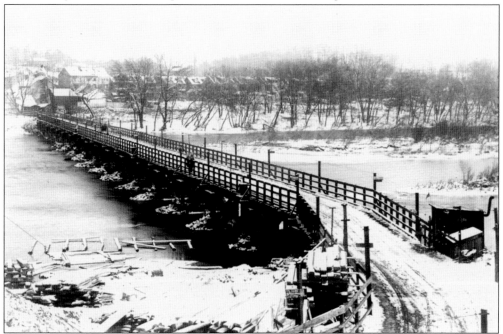

This real-photo postcard produced during the winter of 1917 shows the temporary bridge erected between Phoenixville and Mont Clare that allowed residents to cross between the two places while a new bridge could be planned and constructed. Just out of view is the nearly completed new bridge that would render the temporary bridge obsolete.

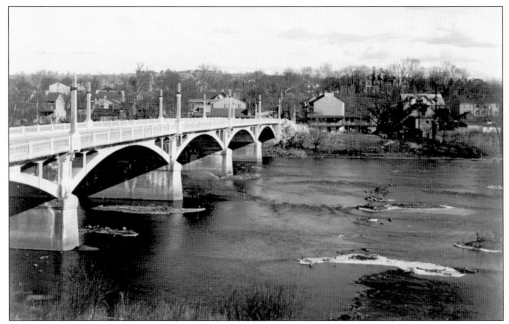

This view from 1921 shows the intercounty bridge, looking toward Mont Clare from the Phoenixville side of the Schuylkill River. By this time, the redundant temporary bridge had been dismantled. The span seen in this image stood for almost eight decades before being replaced with the current bridge that was built in 1997.

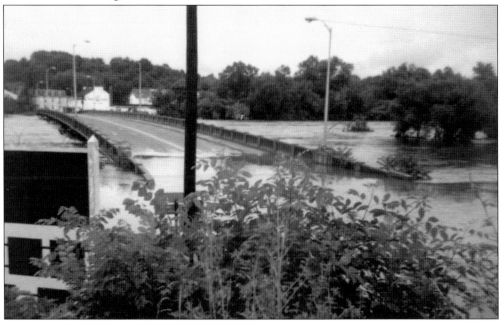

This photograph from the summer of 1972 shows the effect Hurricane Agnes had on the east end of Phoenixville. Rising waters of the Schuylkill River engulfed the bridge between Mont Clare and Phoenixville. Much of Phoenixville and the region at large were overcome by a tide of floodwater. Before the water receded, it was not uncommon to see residents of Phoenixville traveling along parts of Bridge Street in rowboats. (Courtesy of Thelma Alexander.)

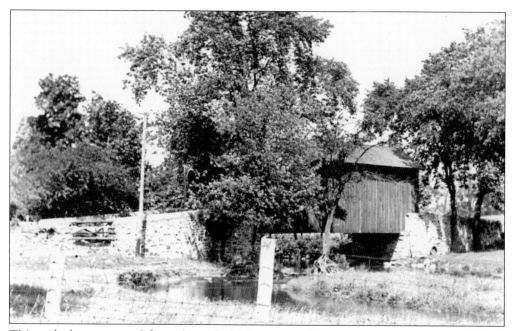

This real-photo postcard from the early 20th century shows the Thompson Davis Covered Bridge that was constructed over the Pickering Creek in 1879. Located just off Route 29 at Creek Road, the covered bridge was replaced by a newer span in 1932. However, the stone walls that anchored both sides of the original bridge are still in place.

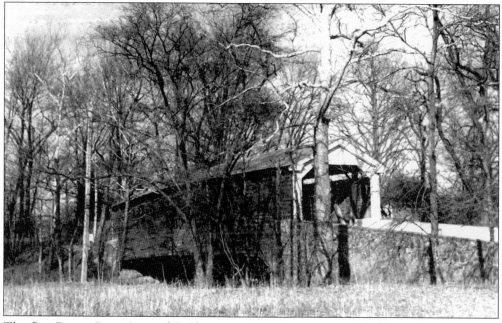

The first Rapps Dam Covered Bridge was originally constructed in September 1866. This real-photo postcard from the 1940s shows the 1920s wooden bridge that crossed French Creek. Part of the bridge would later be damaged by Hurricane Agnes in 1972. However, the bridge was subject to a full rehabilitation in 1977 and continues to carry travelers along Rapps Dam Road to this day.

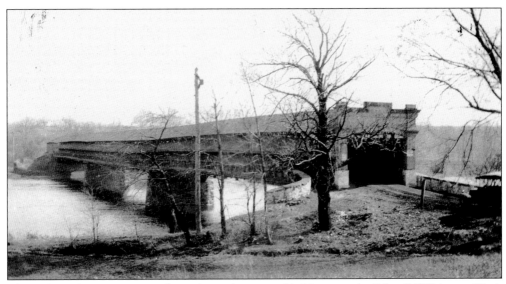

The early-20th-century view above shows the covered bridge over the Schuylkill River at Black Rock on Phoenixville's north side. This view looks over the river, which demarcates Chester County from Montgomery County. Although the region has been home to many covered bridges over the years, this span was certainly one of the most extensive. The covered bridge was replaced decades ago with the more practical span seen below. In the last decade, it too was replaced with a modern bridge that continues to carry thousands of people each day across the county line.

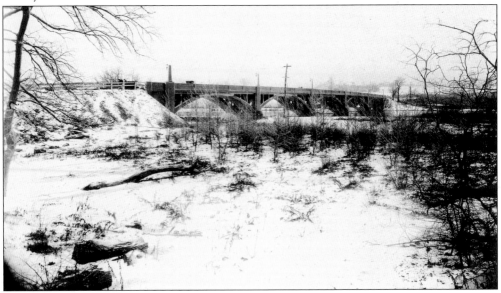

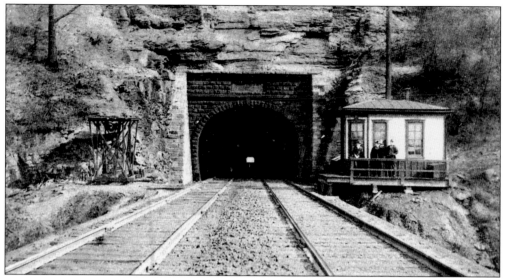

Constructed in 1838–1839, the 1,931-foot-long Black Rock Tunnel is seen in these early-20th-century postcards. Several presumed railway workers stand near a small structure that was used for shelter while performing around-the-clock, year-round activity that kept the trains moving safely through the tunnel. Although the bridge in the foreground is still in use today as a means of crossing the Schuylkill River, the work originally performed by the former rail workers is now automated. As a result, the small structure to the right became obsolete and was demolished long ago.

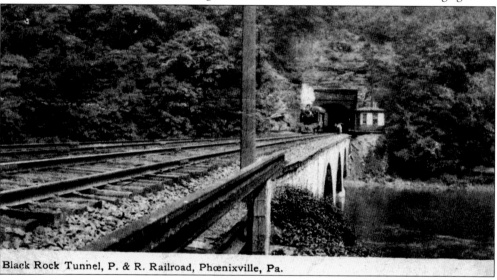

Black Rock Tunnel, P. & R. Railroad, Phœnixville, Pa.

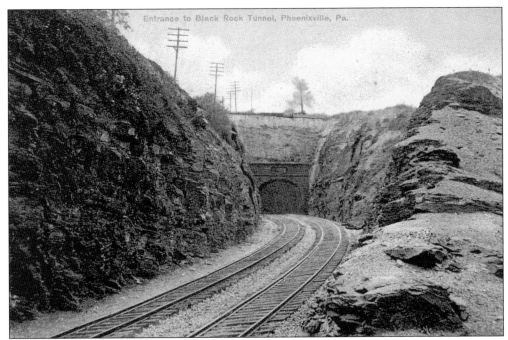

This postcard from 1911 shows the entrance to Black Rock Tunnel. This entryway represents the obverse of the tunnel aperture depicted on the preceding page. One can only imagine the extensive manual labor that was employed to carve this tunnel out of the solid rock that is readily evident on either side of the dual train tracks in this image.

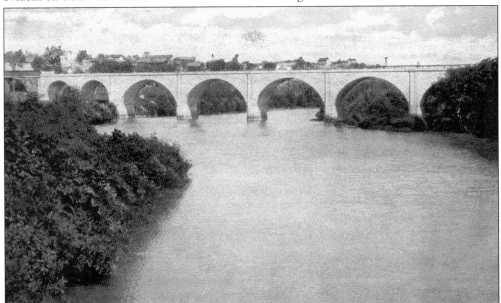

This World War I–era postcard shows the Philadelphia and Reading Railroad bridge that for decades carried trains across the Schuylkill River through Mont Clare and into Montgomery County. In this visual perspective, the bridge is seen from the intercounty bridge that is used by pedestrians and motorists to cross between Phoenixville and Mont Clare along Bridge Street. The bridge still stands today but has been out of commission for quite some time.

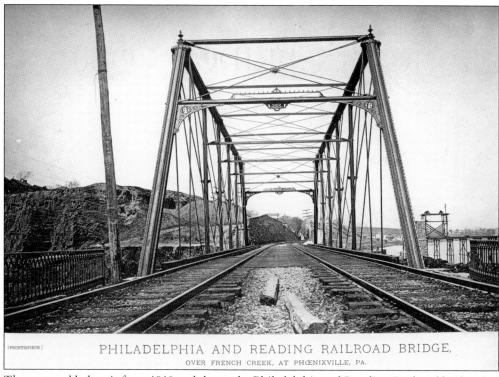

PHILADELPHIA AND READING RAILROAD BRIDGE,
OVER FRENCH CREEK, AT PHŒNIXVILLE, PA.

[FRONTISPIECE.]

The postcard below is from 1910 and shows the Philadelphia and Reading Railroad bridge that once carried trains across the Schuylkill River between Montgomery and Chester Counties. The small bridge partially visible at the left side of the postcard is seen in full view above. This bridge was built locally by the Phoenix Bridge Company and crossed French Creek just before the small tributary emptied into the Schuylkill River. Few Phoenix bridges survive in the immediate area, save for the one that crosses French Creek just outside the former Phoenix Iron Company's foundry building along Main Street.

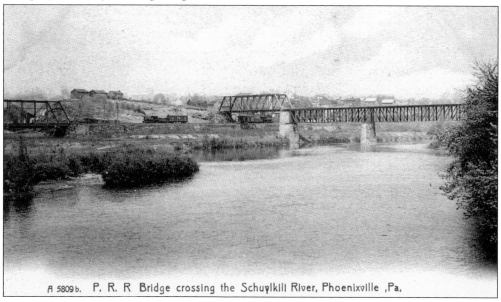

A 5809b. P. R. R. Bridge crossing the Schuylkill River, Phoenixville ,Pa.

79

A photograph and a postcard from 1909 show the Philadelphia and Reading Railroad passenger station located along the Schuylkill River at the east end of Bridge Street. The photograph features the train station from the Mont Clare side of the Schuylkill River in Montgomery County. The small house visible in front of the train station was once used by the caretaker of the covered bridge that spanned the river. The ornate spires that crowned the passenger station were removed long ago; otherwise much of the building looks the same today as it did then. Although trains still run along the tracks, they no longer stop at the station. It now serves the community as a catering hall.

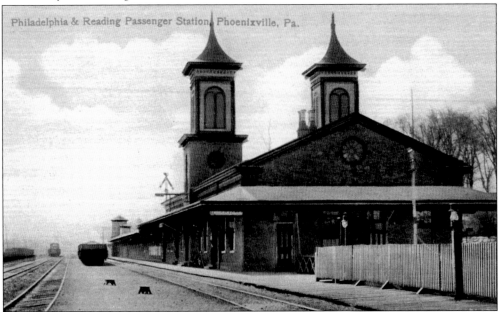

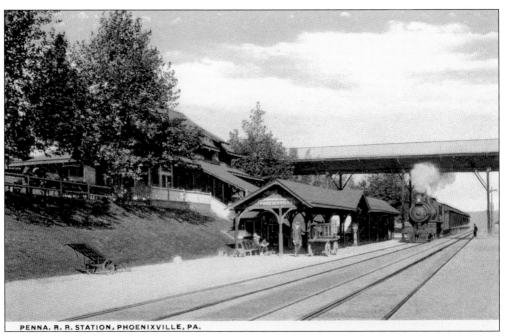

The Pennsylvania Railroad station is seen in the 1912 postcard above. This structure was located along Vanderslice Street, just west of the Gay Street Bridge. This was one of the few train stations that served the Phoenixville community for decades before the need for passenger rail service began to dwindle. Despite vehement protests, the shuttered station was torn down in the late 1980s. Today the site is an overgrown lot with only some steps and a partial foundation to indicate the train station was ever there. In the early-20th-century photograph at right, conductor Absalom Smith poses along the tracks with the station's waiting platform in the background. The old Gay Street Bridge looms in the distance beyond the station.

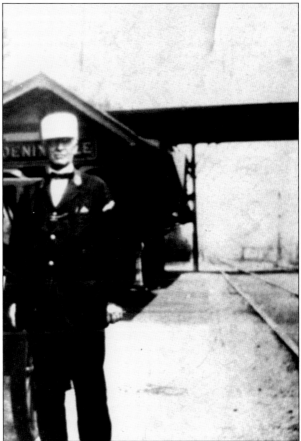

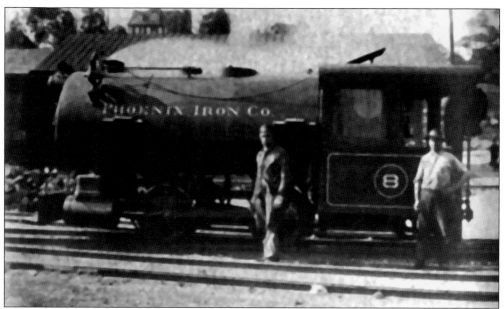

This view from 1910 shows the No. 8 locomotive that belonged to the Phoenix Iron Company. A vast, but intricate network of train tracks traversed the former Phoenix Iron Company site. Trains like this were used to transport materials throughout the scores of industrial acreage that comprised the former iron company. In the background of this image, the upper floors of a large residence that faces Vanderslice Street are visible.

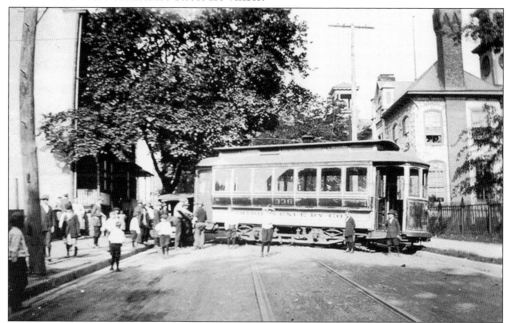

This view from the early 20th century shows a trolley that has derailed in the middle of Church Street, just east of Main Street. A crowd of curious onlookers surveys the scene in amazement. The houses to the left side of the image remain to this day, as do the school and fire company buildings seen beyond the trolley and to the right. Both prominent buildings have received major structural changes over the years and would not be easily recognized today.

Six

CHURCHES AND SCHOOLS

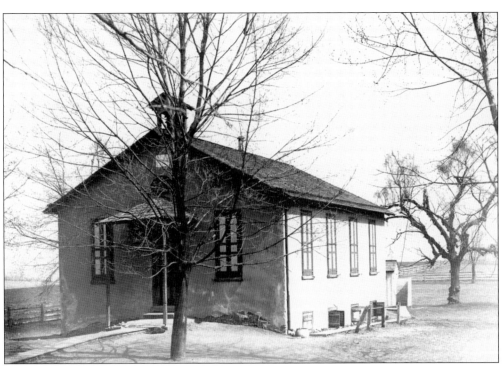

This real-photo postcard from 1905 shows the Oak Grove School that was constructed in the mid-19th century. This structure served a very rural area of Schuylkill Township for many decades before becoming obsolete due to its small size. Today the former school has been adapted for reuse as a residence, and despite a few structural additions, the original school building is still easily recognizable. The old schoolhouse is located along Pothouse Road, across from the entrance to St. Ann's Cemetery. However, the open fields are but a memory of the past, as the property is now surrounded in part by numerous mature trees.

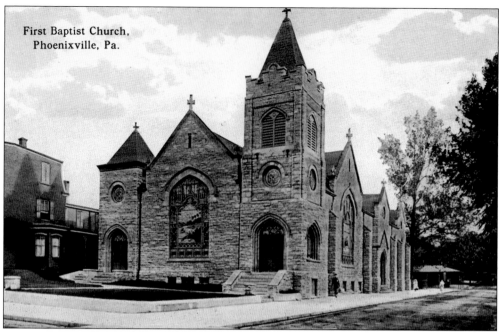

First Baptist Church,
Phoenixville, Pa.

These early-20th-century postcards show the First Baptist Church located at the southeast corner of Church and Gay Streets. The exterior perspective offers a view of the church and pastoral residence. In the interior view, numerous pews sit in front of a large pipe organ that is visible on the left side of this real-photo postcard. Despite a century's elapse, the church has managed to retain much of its original structure and is still easily recognizable today.

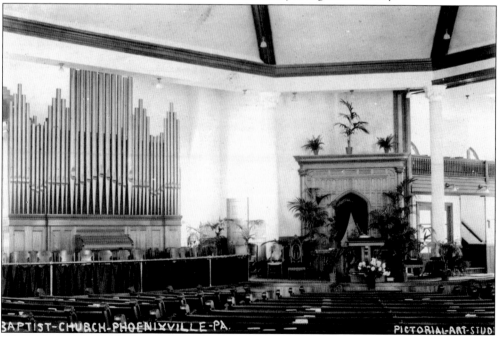

BAPTIST-CHURCH-PHOENIXVILLE-PA. PICTORIAL-ART-STUDI

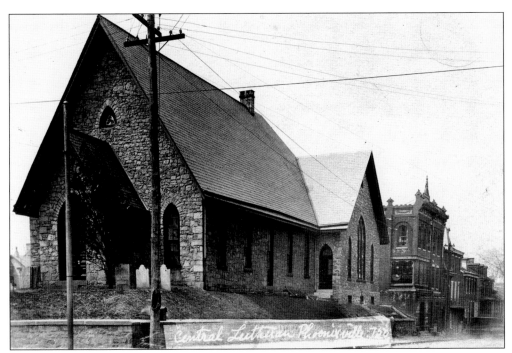

The Central Lutheran Church is seen in this real–photo postcard from 1910. This church operated at the corner of Church and Main Streets for decades. The structure still remains in place today but no longer functions as a church. Curiously enough, the tombstones evident in the churchyard were removed long ago. One can only presume the graves were interred elsewhere at the same time. The buildings immediately visible behind the church were torn down more than 25 years ago to make way for an adjacent bank's parking lot.

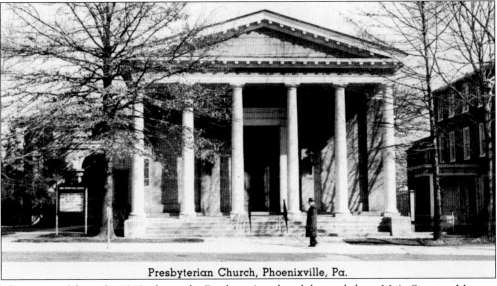

Presbyterian Church, Phoenixville, Pa.

This postcard from the 1940s shows the Presbyterian church located along Main Street at Morgan Street. The exterior of the church has changed very little in the more than 60 years since this postcard was produced. Today the church is still a very active part of the community, with weekly sermons and periodic events.

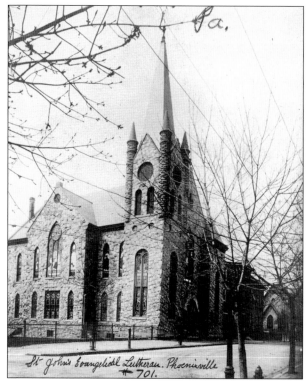

St. John's Lutheran Church is seen in the 1907 postcard at left, and an interior view from the 1950s is shown below. The church was formerly located along Church Street at Jackson Street. It was torn down in the early 1960s to make way for a parking lot owned by an adjacent bank. At that time, the St. John's congregation moved to a new church facility located appropriately enough at St. John's Circle.

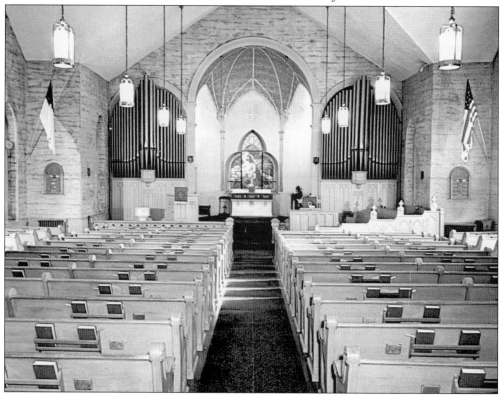

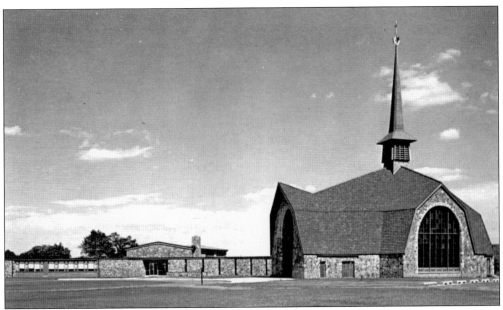

These postcards from the 1960s show St. John's Lutheran Church from an exterior and interior perspective. The church is located on St. John's Circle near Schuylkill Elementary School. Downtown Phoenixville once featured two churches of Lutheran denomination, St. John's and Central. Many years ago, these two institutions merged to become one and relocated to the house of worship pictured here. Today St. John's Lutheran Church continues to welcome a diverse group of worshippers to its services and plays an active role in various community projects.

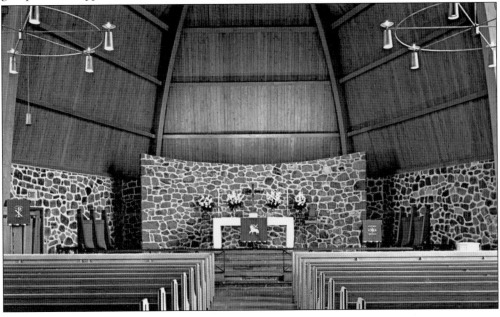

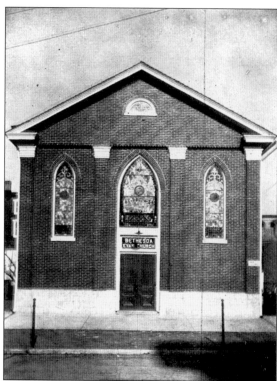

The Bethesda Evangelical Church was located along Morgan Street, just east of Gay Street in this 1915 view. This was one of many churches in Phoenixville that served a diverse religious and ethnic population. Although the building no longer functions as a church, the exterior retains much of its original form and character.

A Quaker meetinghouse is seen in this view from the early 20th century. Located near the intersection of Whitehorse Road and Route 23, the meetinghouse still operates with its original intended purpose. The Schuylkill Meeting House is just one of many such structures that dot the Chester County landscape. Quakerism in Pennsylvania dates back centuries and is still quite viable in this region and beyond.

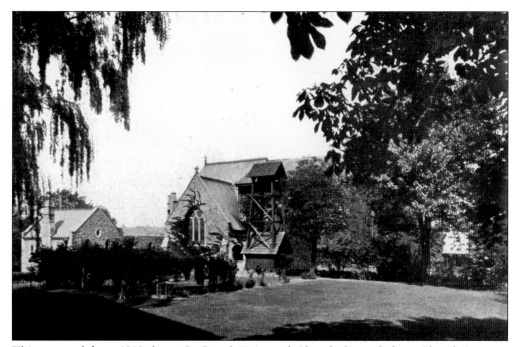

This postcard from 1910 shows St. Peter's Episcopal Church, located along Church Street at Dean Street. St. Peter's is still an active community of worship, and, despite a few alterations to the property, much of the structure remains today as it did then.

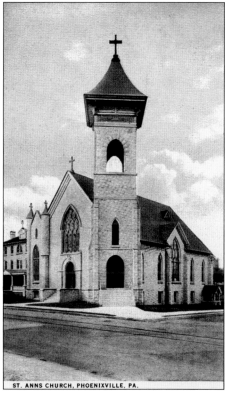

ST. ANNS CHURCH, PHOENIXVILLE, PA.

A 1911 postcard shows St. Ann's Catholic Church and rectory at the corner of Main Street and Third Avenue. This church was made possible by a donation from the Byrne family. The church looks much the same today as it did then, although the bell tower has been enclosed. An interesting note is that several members of the Byrne family are entombed in a crypt at the rear of the church, a rare example of nonclergy being laid to rest within a house of worship.

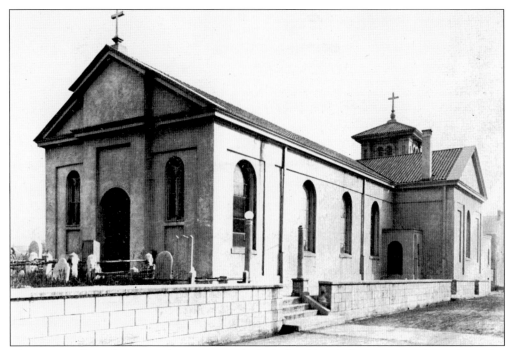

These views from the 1920s show St. Mary's Catholic Church from an exterior and interior perspective. The image above shows the church as it appears from the corner of South and St. Mary's Streets. Although the wall has been fortified over the years, the church building looks remarkably similar today. As well, the interior of the church is still easily recognizable. St. Mary's Catholic Church continues to serve a diverse population of worshippers as one of four Catholic churches in Phoenixville.

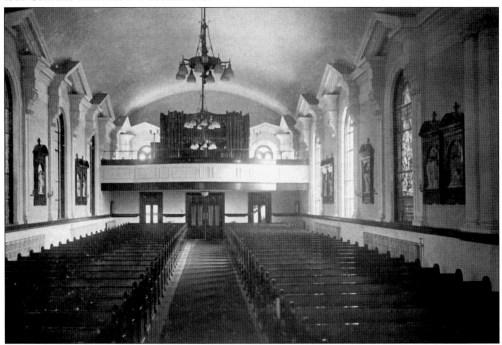

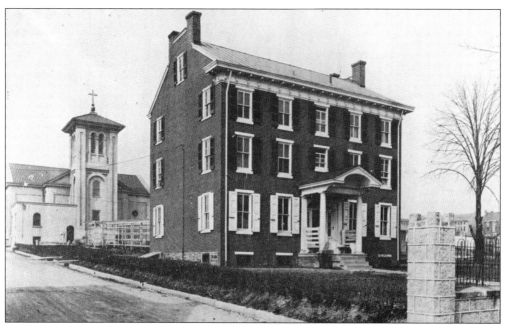

This photograph shows the St. Mary's rectory as seen from the corner of Dayton and St. Mary's Streets. On the right, some houses can be seen along Emmett Street in the background. However, the church itself is one of the most prominent features in this view. This structure has changed little in the 80 years since this photograph was produced.

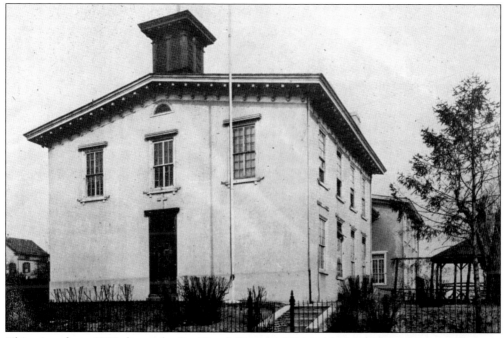

This view from 1915 shows the St. Mary's Parochial School located along Emmett Street on Phoenixville's north side. Years later, a new parish school was constructed to the rear of this building. The former school has been adapted for reuse as St. Mary's Homeless Shelter but is still easily recognizable today.

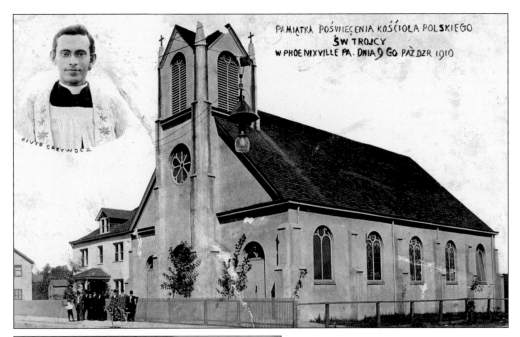

PAMIĄTKA POŚWIĘCENIA KOŚCIOŁA POLSKIEGO
ŚW TRÓJCY
W PHOENIXVILLE PA. DNIA 9 GO PAŹDZR 1910

REV D GRZYWOCZ

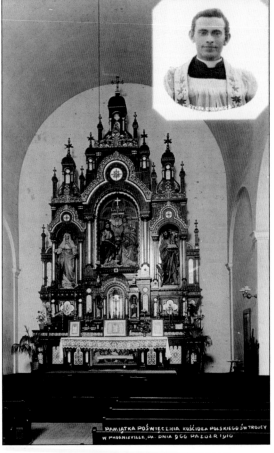

PAMIĄTKA POŚWIĘCENIA KOŚCIOŁA POLSKIEGO ŚW TRÓJCY
W PHOENIXVILLE, PA. DNIA 9 GO PAŹDZR 1910

These real-photo postcards from 1911 depict an exterior and interior view of Holy Trinity Catholic Church, located along Dayton Street on Phoenixville's north side. The church opened in 1910 under the pastorship of Rev. Francis Grzywacz, pictured on both postcards. As is evident by the text featured on the postcards, this parish was formed and used by a primarily Polish population. In the view above, the rectory and part of the former school are visible. Despite some modifications, the structure is easily recognizable almost a century after its construction was completed. Today worshippers continue to congregate at the church as it remains an active community institution.

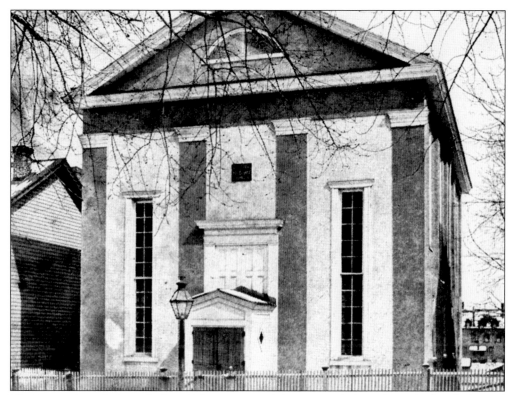

The image above is from the late 19th century and shows St. John's Reformed Church, located along Church Street between Jackson and Dean Streets. Years later, this structure functioned as a Methodist church subsequent to St. John's Reformed Church moving to its current location along Gay Street. The postcard below shows an early-20th-century side view of the structure when it was operating as the Methodist church. Today this building functions as the Phoenixville Senior Center. Although more than a century has elapsed since these views were produced, the former church is still easily recognizable. The homes visible on the right in the image above still stand on Prospect Street behind the church. In the image below, the former Church Street School is partially visible along the left side.

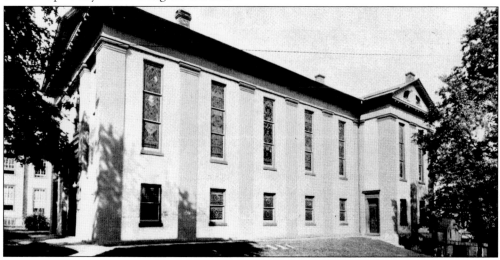

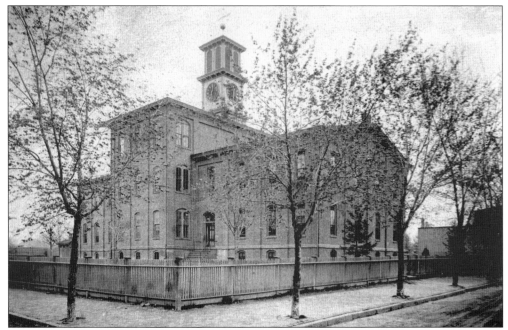

This real-photo postcard from 1905 shows the Gay Street School as seen from the intersection of Morgan and Gay Streets. Many residents will recognize the four-sided clock at the top of the school, visible from almost any vantage point in town. It has been almost 30 years since the building served as a school, having been converted into apartments and small office suites in the 1980s. Much of the original structure remains intact today.

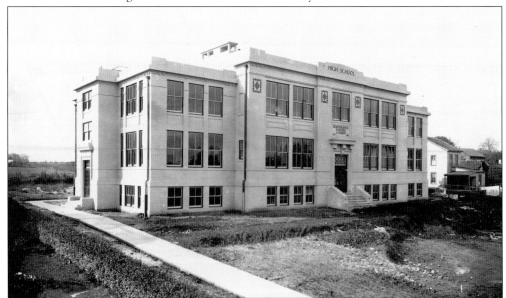

Phoenixville High School is seen in this view from 1911 shortly after being constructed. The building served the community well until the present-day high school opened in 1956. The structure, made of steel-reinforced concrete, was torn down decades ago to make room for expansion of the Phoenixville Hospital, which still occupies the site along Nutt Road at Gay Street.

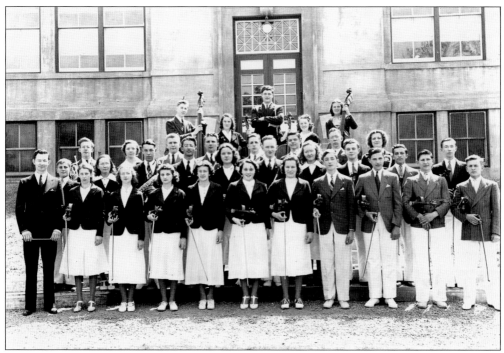

These photographs from the 1940s show the Phoenixville High School band standing proudly in front of the former high school building that was located along Nutt Road at Gay Street. Each image represents the band attired for separate events, with respect to the nature of the performance and venue. The school in the background was torn down in the 1950s to make way for an expansion of the Phoenixville Hospital. The students were redirected south on Gay Street to the building that still serves as the present-day high school.

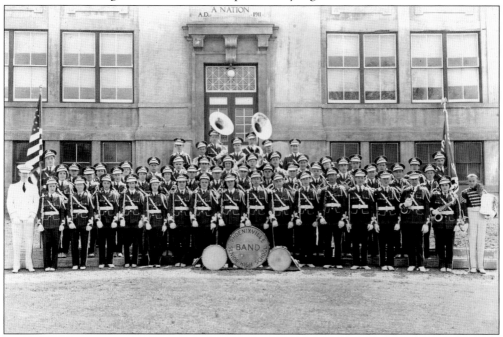

This view from 1911 shows an octagonal schoolhouse that was once located along east Bridge Street, adjacent to the superintendent's building on the grounds of the Phoenix Iron Company. The little structure was torn down decades ago as it had been deemed obsolete. Inexplicably, several barrels of unknown content are stacked next to the building.

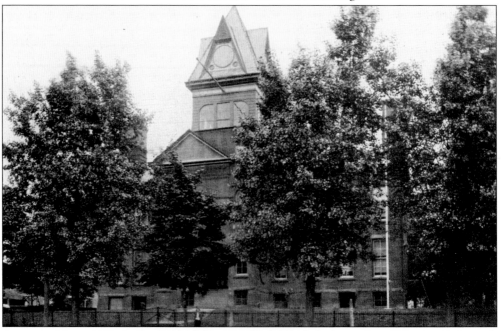

A postcard from 1910 shows the High Street School, formerly located on Phoenixville's north side, adjacent to Friendship Fire Company. The school was built in the late 19th century and torn down many years ago. Today a playground sits in its place.

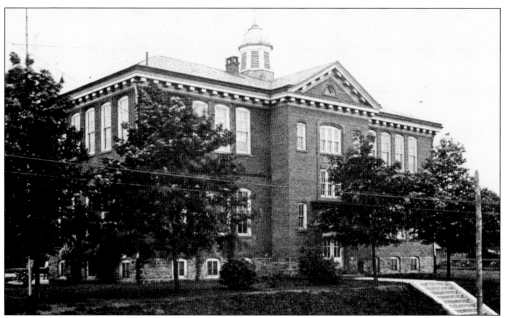

The Mason Street School was one of several elementary schools located in Phoenixville over the years. The cornerstone on this building says 1910, and this view shows the school as it appeared just five years later. The school functioned for more than 70 years before closing in the spring of 1983. The next 20 years would see the school and its grounds used for a variety of commercial purposes. Today the building still sits along Nutt Road at Mason Street and has been carefully restored by its new owner, Phoenixville Federal Bank and Trust.

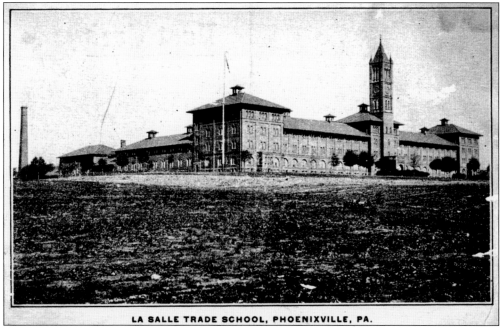

LA SALLE TRADE SCHOOL, PHOENIXVILLE, PA.

The La Salle Trade School is seen in this postcard from 1910. Located off Pawlings Road and visible from Route 422 in Oaks, the building shown here was constructed more than 100 years ago. Today the facility is known as St. Gabriel's Hall and provides care for delinquent male youth.

This postcard from the early 1950s shows Memorial Junior High School, located along Second Avenue at Lincoln Avenue. The building was constructed in 1930 and underwent a complete renovation during the 1990s aimed at meeting modern educational standards. Since 1963, the building has served as Samuel K. Barkley Elementary School.

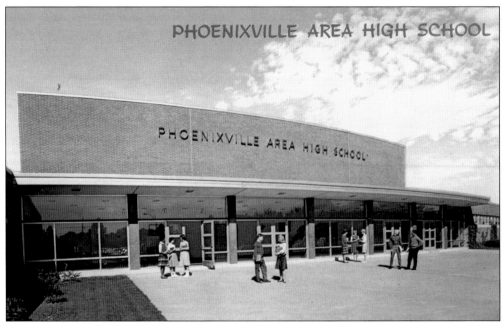

Phoenixville Area High School was built in 1956. Located at the southwest corner of Gay Street and City Line Avenue, the school has since undergone a massive renovation aimed at accommodating a growing population and new demands in education. Although the facade has not changed significantly since this early-1960s postcard, there have been some small modifications.

Seven

SPORTS AND RECREATION

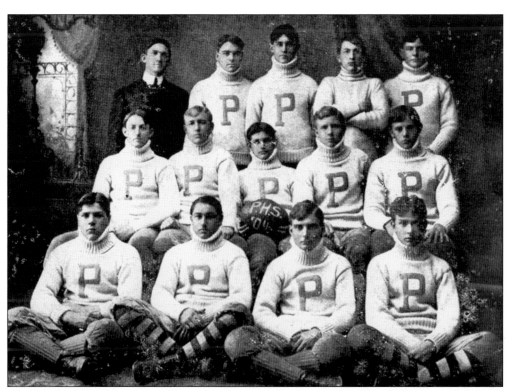

This photograph from 1904 shows the Phoenixville High School football team. The squad of 13 players and the coach pose formally around a game ball in a photographer's studio. The players are dressed in what would have been typical uniforms for the time period. In addition, the coach is formally attired in a suit and tie. This view certainly represents a marked contrast from the bright padded uniforms common to modern-day football players.

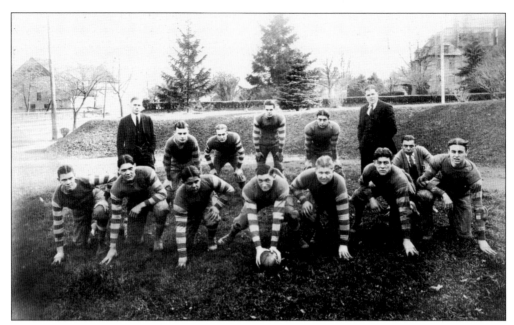

This World War I–era real-photo postcard shows the Phoenixville High School football team posing in front of the school at its location along Nutt Road, just east of Gay Street. In this view, the old Phoenixville Hospital can be seen in the background and to the right. On the north side of Nutt Road is a barn whose former location is now home to several commercial establishments.

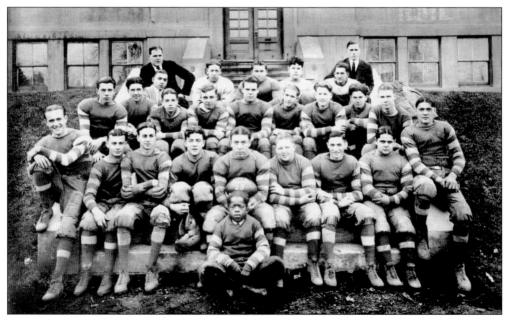

This real-photo postcard shows the 1923 Phoenixville High School football team sitting on the front steps of the school facing Nutt Road. The squad is considerably larger than it had been just a few short years before. Also, it is evident that some players wore pads beneath their uniforms to help prevent injury. The school was built in 1911 and torn down less than 50 years later.

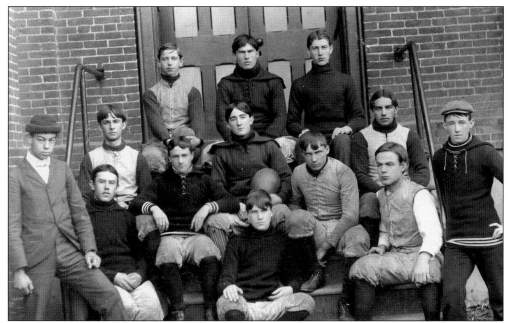

This photograph from 1896 shows the Phoenixville High School football team gathered on and around the steps of the Gay Street School. Prior to construction of the high school on Nutt Road, the Gay Street School functioned as Phoenixville's high school. The steps still remain today, facing Morgan Street.

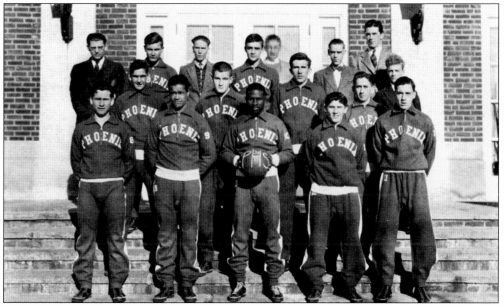

This photograph from 1939 shows the Phoenixville High School basketball team standing on the steps of Memorial Junior High School, located along Second Avenue between Quick Street and Lincoln Avenue. Today the former junior high school still functions as Samuel K. Barkley Elementary School.

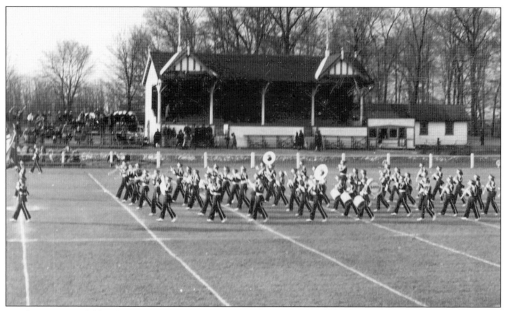

Washington Field has been home to Phoenixville High School football for decades. Located along City Line Avenue between Main Street and Gay Street, the field is seen in a 1944 photograph, showing the original wood grandstand. The field still hosts football and a variety of other sporting events. In this view, the high school band marches across the 50-yard line. The grandstand was torn down long ago. (Courtesy of the Lessig family.)

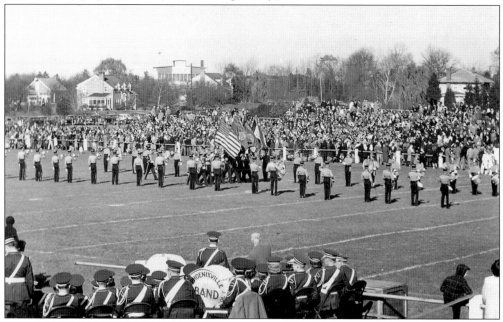

This photograph from the 1940s shows the Phoenixville High School band in the foreground viewing another band's demonstration on Washington Field during halftime of a football game. The field stills hosts football games, graduations, and other events. In this image, the structures visible in the background are located beyond the northwest corner of Gay Street and City Line Avenue. (Courtesy of the Lessig family.)

This real-photo postcard shows Washington Field looking toward Main Street in the 1920s. Numerous spectators can be seen sitting in the background watching the game as the players line up in formation. Today modern bleachers and ample standing room provide those attending the game with plenty of viewing space and a total capacity that numbers in the thousands.

A real-photo postcard from the 1920s shows the Phoenixville High School baseball team in action at Washington Field. In this image, players, a coach, and an umpire watch intently as the runner heads toward third base. This view looks northwest toward the intersection of Gay Street and City Line Avenue. Today Washington Field still plays host to baseball games; however, the field is located closer to the Main Street side of the field.

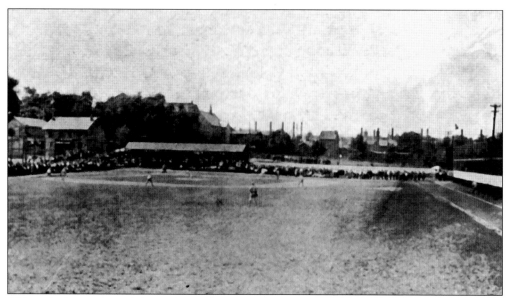

This real-photo postcard shows the Union Club athletic field. The Union Club was a local sports club established in the early 20th century. This field was located along Starr Street and bordered by Church Street at its northern fringe. Beyond the roof of the small grandstand, St. Peter's Episcopal Church is partially visible from its location along Church Street. The smokestacks of the Phoenix Iron Company can be seen in the distance. Today the field is long gone, and houses have been constructed in its place.

This real-photo postcard from the early 20th century features a local football player striking a standard pose in between two buildings located along Church Street. The stone structure visible just beyond the player is the former St. John's Lutheran Church that was located along Church Street at Jackson Street. (Courtesy of the Lessig family.)

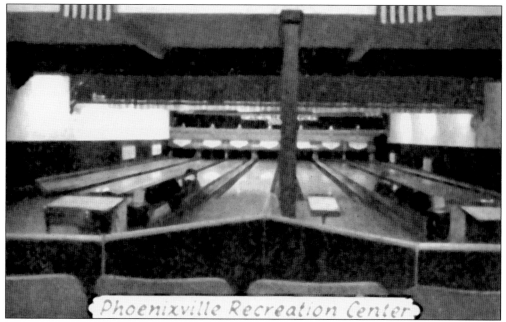

The seven-lane bowling alley of the Phoenixville Recreation Center is seen in this view from the 1940s. The recreation center occupied the former National Bank of Phoenixville building located at 225 Bridge Street in the downtown. Subsequently, the building was occupied successively by the offices of the *Daily Republican*, *Evening Phoenix*, and *Phoenix* newspapers.

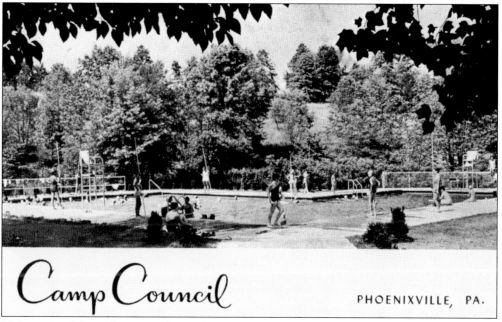

This postcard from the 1950s shows the swimming pool at Camp Council. This facility was located in then-rural Phoenixville and was one of many camps located in the area. Today the camp is just a distant memory, its property having since been sold and redeveloped for residential purposes. The name lives on in the form of Camp Council Road, home to numerous houses not far from Route 23 and French Creek at the site of the former camp.

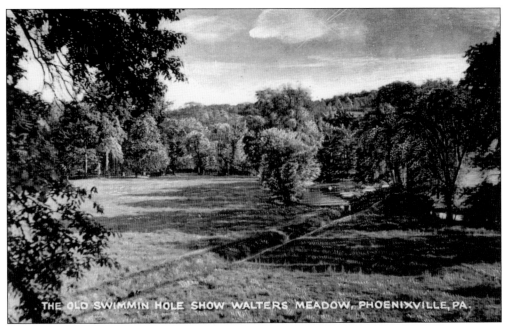

THE OLD SWIMMIN HOLE SHOW WALTERS' MEADOW, PHOENIXVILLE, PA.

A postcard from the 1930s shows the swimming hole located on the Showalter farm, the name of which has been misspelled on this postcard. Still operating as a farm in the late 1980s, this land was sold and developed at the close of the 20th century. The author's family spent decades farming this plot of land on Pothouse Road, just west of Route 29. Despite the subdivision of the land, the barn, 1803 farmhouse, and some outbuildings still exist among the new homes.

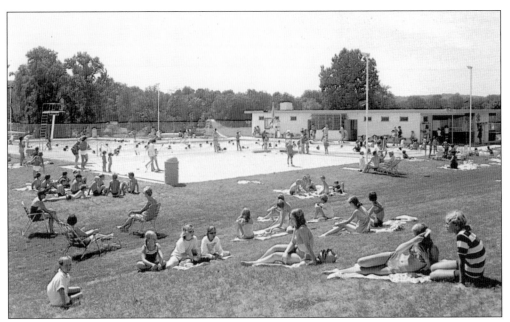

This postcard from the early 1960s shows the Baker Park swim club, replete with pool-goers on what must have been a warm summer day. This area is located within the grounds of the YMCA, along Pothouse Road. Baker Park still operates and is easily recognizable as much of the original infrastructure remains today.

Eight

PARKS AND MONUMENTS

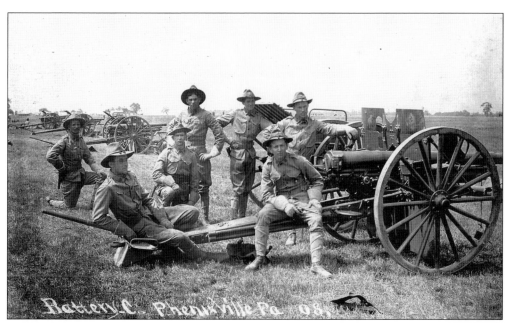

A real-photo postcard from 1908 shows members of the Battery C military detachment posing around a Griffen gun. This weapon was produced at the Phoenix Iron Company facility on east Bridge Street and had been developed for the Union effort during the Civil War. The Battery C armory building was located on Buchanan Street at Morgan Street and was torn down in the 1980s.

A postcard from 1909 shows the entrance to Reeves Park at the southeast corner of Main Street and Second Avenue. Although the overhead sign is gone, steps still remain in place and permit access to the park from this location. Today there are far fewer trees in the park than there were a century ago.

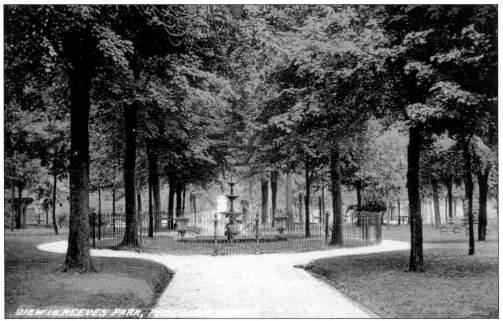

The primary entrance to Reeves Park is located along Main Street between Second and Third Avenues. In this postcard from 1910, an ornate fountain is visible within a circular fence. Today the fence remains but the fountain is gone, replaced with shrubbery. Overall the park has managed to retain much of its original charm and is still used by residents and civic organizations for a variety of recreational purposes.

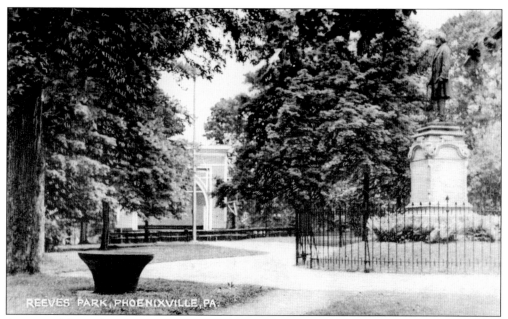

A postcard from the 1930s shows a view in Reeves Park, looking toward the band shell. The statue was built to honor David Reeves, a 19th-century industrialist who was largely responsible for the development of the Phoenix Iron Company. The planter on the left side of the image is actually an inverted school bell. This view has changed very little over the last eight decades.

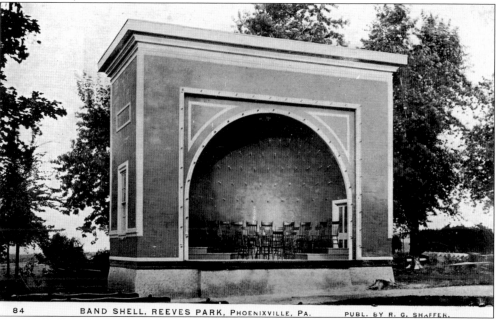

This early-20th-century postcard shows the band shell located in Reeves Park, facing Main Street. Built at the dawn of the 20th century, the band shell has been the centerpiece of the park for decades and has played host to a variety of acts over the years. The beveled-edge wood benches and undeveloped fields in the background have been lost to time and progress. The park is now home to a playground, ball field, and various community events.

This view from the 1940s shows a monument constructed to honor veterans. The verbiage makes reference to the fact that the monument was "erected by the citizens of Phoenixville" for the "honored dead." It also features the number 1,534, which indicates the number of residents serving in the military at that time. This monument was once located along Gay Street next to the post office. Today the former site is now a parking lot. (Photograph by Viola Batzel.)

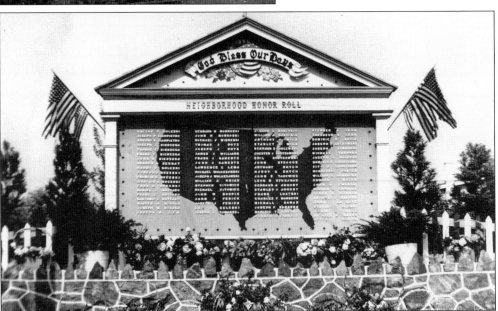

This World War II–era view shows a temporary monument that had been erected at the northeast corner of High and Dayton Streets on Phoenixville's north side. Adorned by American flags, the signage indicates this monument was designed as the "neighborhood honor roll" and says "God Bless Our Boys" at the top. The full names of servicemen from the community were listed on the monument. Although the monument is long gone, the old stone wall remains in place today. (Photograph by Viola Batzel.)

A 1906 postcard shows the soldiers' monument located in Morris Cemetery. The monument was erected in 1871 to commemorate Civil War dead from Phoenixville and is still visible from numerous vantage points along Nutt Road.

This 1910 postcard shows the Revolutionary War monument, marking the farthest point reached inland during the British invasion. The monument sits on a small island of grass at the busy intersection of West Bridge Street and Nutt Road. The small fountain pool behind the monument is long gone, as is the open pasture along the north side of Nutt Road. Today houses sit in the former field, and this stretch of road is one of Phoenixville's most heavily traveled.

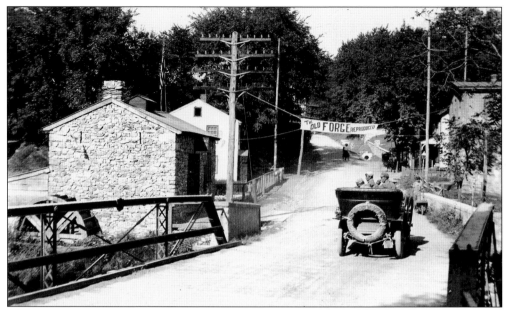

This early-20th-century view shows Route 23 heading west out of Valley Forge. As one can see, significant development had taken place at the county line between Chester and Montgomery Counties. The small stone building to the left has a sign that says "Souvenir Shop" and boasts a waterwheel on the side. Today only the small white house in the background remains in what is now Valley Forge National Park.

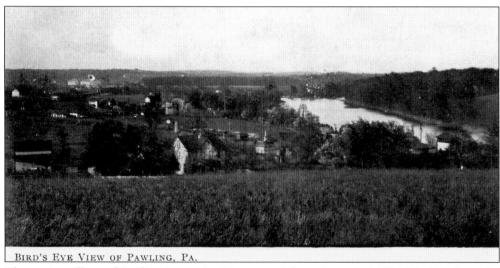

BIRD'S EYE VIEW OF PAWLING, PA.

The quaint village of Pawling is seen in this postcard from the early 1900s. Nestled along the Schuylkill River between Phoenixville and Valley Forge, the small area has seen only sparse development over its extensive history. This bucolic scene shows several distinct farms and residences near the river's edge. This area can be seen from Pawlings Road, just off Route 23 in Schuylkill Township.

Nine

CHARLESTOWN AND KIMBERTON

This real-photo postcard from 1905 shows a group of people at Camp Hoffman, just off Rapps Dam Road in Kimberton. In this view, numerous adults and children of varying ages have seemingly gathered at the camp for some type of celebration, as evidenced by the small American flags hanging in the background to the left of the candy-striped canopy that provided shelter from the summer sun. In looking at this image, one can only imagine the accompaniment of manual labor that took place amid the festivities, evident by the pickax and shovel wielded by two of the gentlemen in the photograph.

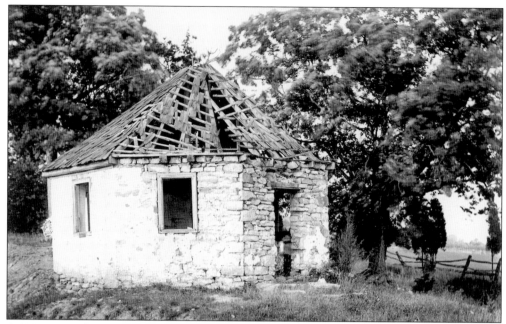

A 1902 view of the one-room schoolhouse on Diamond Rock Hill shows the little building in a sad state of disrepair. Two decades later, an updated image reveals that the schoolhouse has been restored. This early work effort illustrates the proclivity of the citizenry toward favoring preservation over demolition, long before restoration of historic structures in Phoenixville would be in vogue. Located on the outskirts of Phoenixville, this small school served children of many ages from this rural locale. The school was originally built in the early 19th century and was first restored in 1909. Today the building is one of few surviving one-room schoolhouses in the region and is maintained by a volunteer group.

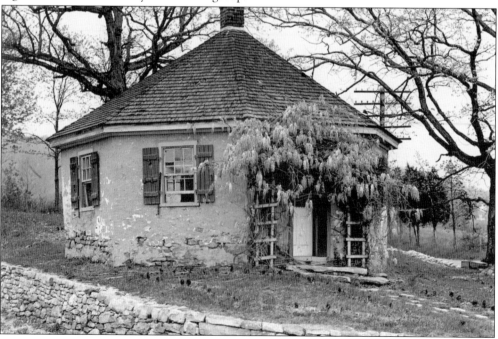

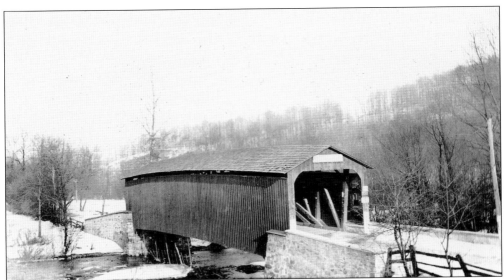

Located along Route 29 in Charlestown Township is a small bridge called Ice Dam Bridge that crosses a shallow section of Pickering Creek. It was erected in 2001 to replace an older span that had seen better days. However, preceding both of these was a covered bridge. The view above shows the mid-19th-century covered bridge as it appeared in 1905 on a snowy winter's day. The view below shows the more modern span shortly after its completion in 1926, having replaced the covered bridge. Although neither of these bridges still exists, the community is fortunate in that the surrounding landscape remains practically unchanged.

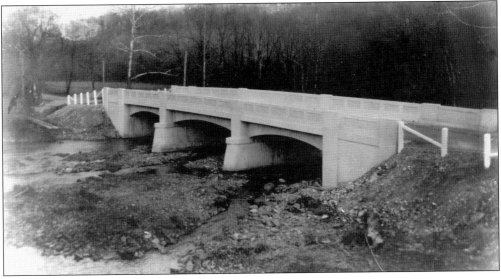

Charlestown Consolidated School

The Charlestown Consolidated School was built in 1925 and sits along Charlestown Road, not far from Route 29. The old stone structure faces an open field, a rare sight in many parts of northern Chester County today. Although this original building still exists and is used as an elementary school, several renovations and additions have been made to the structure over the years. The facade remains virtually unchanged from this 1927 view, and the building is easily recognizable today.

According to the text on the reverse of this postcard, Swiss Pines was a "preserve for the study of horticulture, ornithology and conservation." At the time of this postcard's production in the 1960s, Swiss Pines was being administered by the Academy of Natural Sciences of Philadelphia. The preserve has not been given regular maintenance and care in modern times. As a result, the property located along Charlestown Road at the center of the township is but a shadow of its former self.

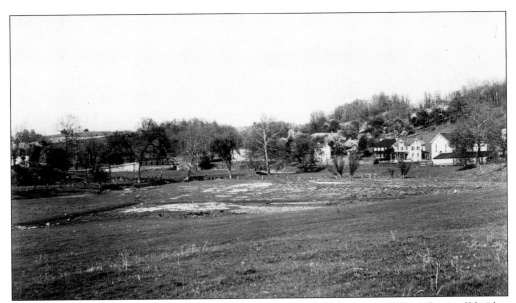

This real-photo postcard looks east across the village of Charlestown in 1903. The small bridge near the center of the image crossed over the creek that runs under Charlestown Road. Toward the right side of the view, the Charlestown United Methodist Church is visible. This house of worship was originally constructed in 1840 as the Methodist Episcopal church and was enlarged in 1881. The two houses to the left of the church remain today, but the stable across from the structure exists no more.

This real-photo postcard shows the lake at Kimberton, not far from Hares Hill and Kimberton Roads. Although more than 85 years have elapsed since this image was produced, Kimberton still maintains much of its quiet, rural character. While the population has increased steadily over the years, the many wide-open spaces in Kimberton are a welcome contrast from densely populated Phoenixville.

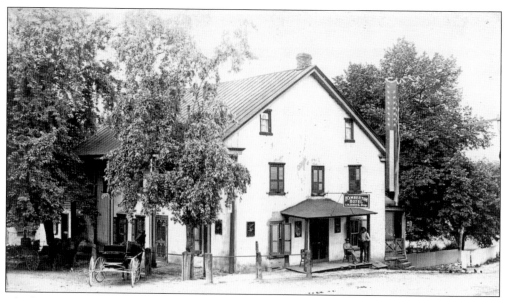

The former Kimberton Hotel is located at the corner of Hares Hill and Kimberton Roads as seen in this real-photo postcard from 1906. At that time, the business's main entrance was just steps off Kimberton Road. The horse-drawn carriages are parked along Hares Hill Road. Subsequent renovations modernized the building, but much of the original structure remains intact. The building dates to 1796 and is still easily recognizable as a landmark in the small village. Today the building operates as a restaurant called the Kimberton Inn. Below, a postcard from the 1960s depicts the restaurant when it was known as the Kimberton Tavern.

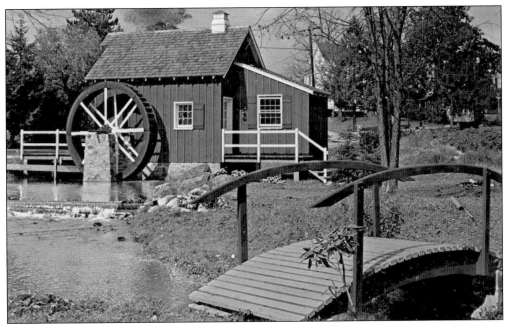

This waterwheel is located on the grounds of the Kimberton Inn, facing Hares Hill Road. Little has changed since this postcard was produced in the early 1960s, and the landscape surrounding the waterwheel still makes for great photograph opportunities. The ornamental wheel is an appropriate homage to the area's past.

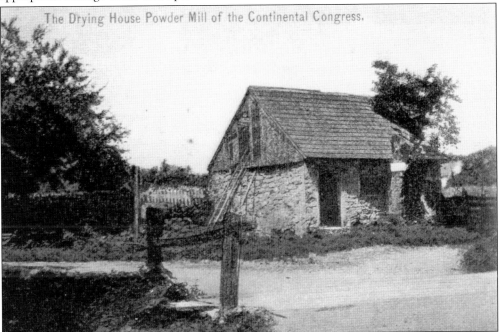

The Drying House Powder Mill of the Continental Congress.

This early-20th-century postcard shows a view of "the Drying House Powder Mill," with an indication that it was used by the Continental Congress during the Revolutionary War effort. This dates the mill to at least the late 1700s. Today the ruins of the little mill can be seen as one emerges from the covered bridge on Rapps Dam Road.

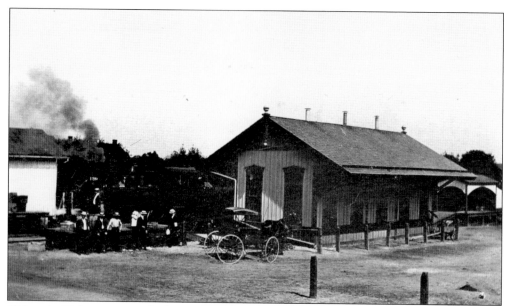

This early-20th-century real-photo postcard shows the train station in Kimberton. This station is located along Kimberton Road, just up the hill from the Kimberton Inn. Although trains ceased to run past this spot years ago, the station has been adapted for reuse and has housed numerous commercial enterprises over the years.

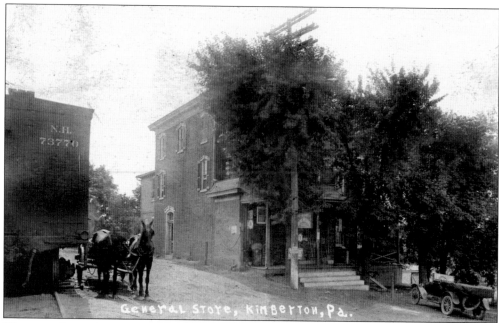

The general store in Kimberton is seen in this real-photo postcard from 1912. The general store was located directly across from the train station and served the small village for many years. Today the tracks that crossed Kimberton Road have been removed, and the former store has been converted to a residence. This view showcases three separate modes of transportation: rail, horse-drawn carriage, and automobile.

Ten

MONT CLARE

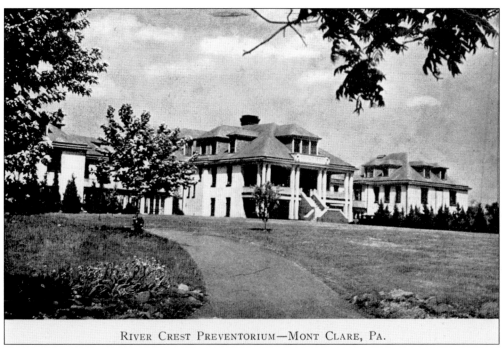

RIVER CREST PREVENTORIUM—MONT CLARE, PA.

This postcard from 1918 shows a building complex once known as the River Crest Preventorium. In this context, it was thought that quarantining sick people (as well as those who showed symptoms of illness) could effectively prevent the spread of disease to unaffected individuals. Today the term *preventorium* is unlikely to turn up in many dictionaries and in the vocabulary of most Americans. The complex and its mission evolved over the subsequent decades and served the needs of handicapped persons through the 1990s. Set back from Route 29 on the way to Collegeville, the former preventorium was ultimately developed as a golf course and housing community known simply today as RiverCrest.

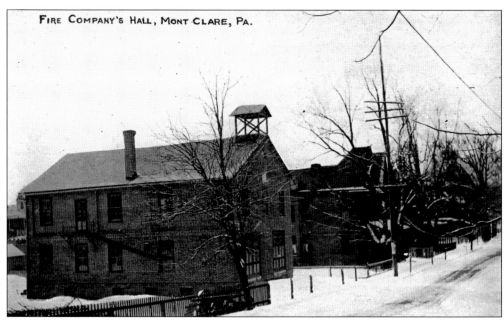

FIRE COMPANY'S HALL, MONT CLARE, PA.

A postcard from 1909 shows the fire company's hall located along Bridge Street, just east of Port Providence Road. The view at the top shows the original building, along with a bell tower that would sound whenever a fire broke out. The excess land around the fire company would later be utilized to accommodate an addition to the original firehouse, as well as a small residence to the building's right. The photograph below was taken in the late 1990s in the days preceding the firehouse's demolition in preparation of being replaced with a contemporary structure better equipped to meet the needs of modern firefighting. The old houses seen in the postcard remain as residences to this day.

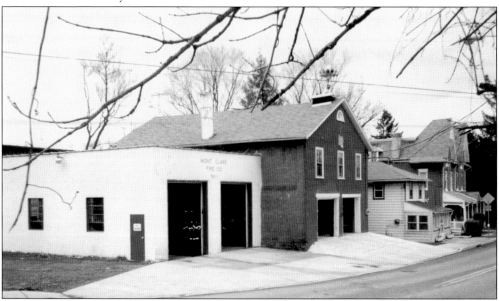

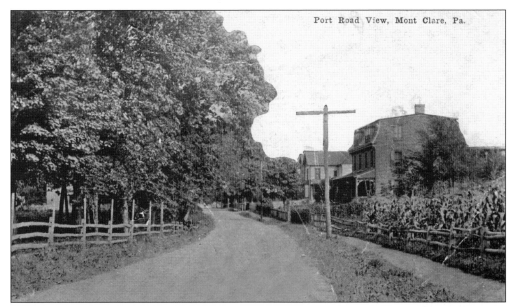

This postcard from 1906 shows a couple of homes set amid what was once a very rural setting just beyond the bank of the Schuylkill River. These homes are located along Port Providence Road, just past Needle Street. As one would imagine, the former cornfield in the foreground has been developed and is now home to several residences.

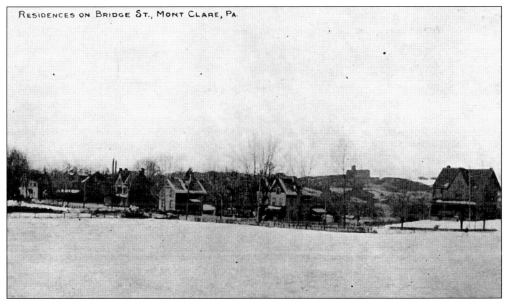

At its western end, Bridge Street begins at Pothouse Road on Phoenixville's border with Schuylkill Township. In an eastward direction, Bridge Street extends across the Schuylkill River and into Mont Clare. This postcard from 1909 shows several residences lining Bridge Street between Jacob and Amelia Streets. Today several more homes have been built in this neighborhood around those that existed in 1909.

Athletic Grounds, Mont Clare, Pa.

These early-20th-century postcards depict alternate views of the athletic grounds located at the Jacob Street terminus in Mont Clare. In the image above, the rudimentary baseball diamond is surrounded by cornfields and forestation. The image below looks toward home plate from the vantage point of second base. In this view, several residences in addition to the top of St. Michael's Byzantine Catholic Church on the hill can be seen. The field remains in use today and is owned by the St. Michael's parish.

VIEW FROM ATHLETIC GROUNDS, MONT CLARE, PA.

Schuylkill River View, Mont Clare, Pa.

This 1909 postcard shows a view of the Schuylkill River, looking south from the intercounty bridge that links Phoenixville with Mont Clare. This tranquil scene appears very similar today to what it looked like a century ago. However, the former Heine Safety Boiler Company building visible in the postcard is now mostly obscured by mature trees.

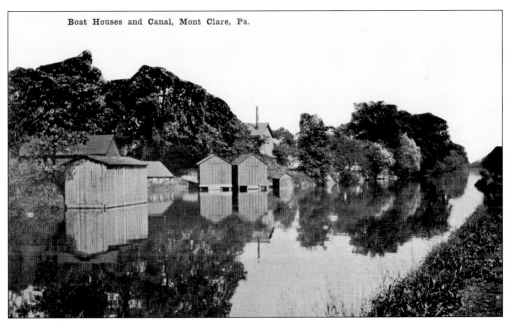

Boat Houses and Canal, Mont Clare, Pa.

This postcard from 1909 shows several small houses located along the canal that runs parallel with the Schuylkill River in Mont Clare. Today the canal is used for recreational purposes, whereas it was once used to transport coal and other materials throughout the region. The small dwellings that lined the bank are but a memory today.

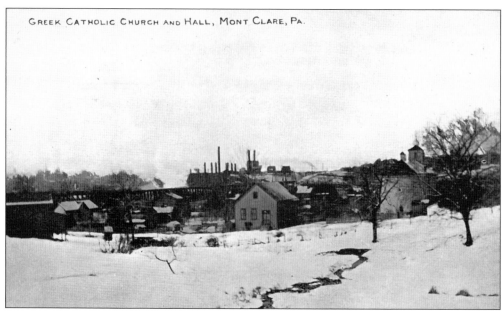

GREEK CATHOLIC CHURCH AND HALL, MONT CLARE, PA.

This postcard from 1909 shows the Greek Catholic church and hall, known formally today as St. Michael's Byzantine Catholic Church. St. Michael's was established in 1897 and is still a thriving parish and center of the community from its location at Amelia and Landis Streets. In the background of this view, a portion of the Phoenix Iron Company plant is seen in the distance across the Schuylkill River.

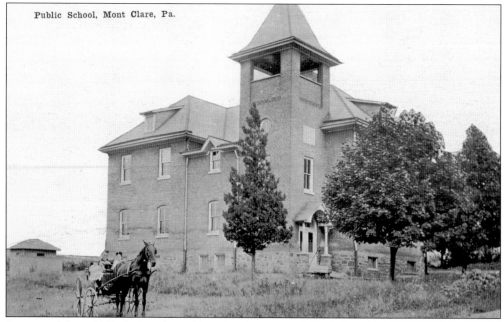

Public School, Mont Clare, Pa.

A postcard from 1909 depicts the public school in Mont Clare. A lone horse-drawn carriage sits idle in front of the school, perceptibly located in a rural area at that time. Today the school has been converted to an apartment building. Despite numerous modifications, one can still recognize the former school in its location at Norwood Street and Whitaker Avenue. An interesting aspect of this postcard is the outhouse located on the left.

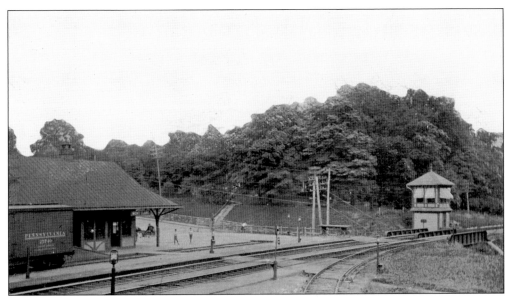

This postcard from 1909 shows the railroad station at Mont Clare. In this view, a Pennsylvania Railroad boxcar sits on the tracks in front of the station. In addition to the station, there was also a small signal tower that once sat over Route 29. Today almost everything visible in this image from the early 20th century is but a memory. Nothing remains of the station or signal tower. The old bridge continues to sit over Route 29, and the set of stairs going up the hill in the middle of the postcard still leads to a grand residence.

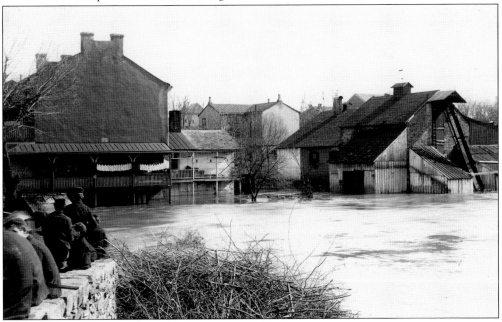

This image from 1902 shows how high the floodwaters had risen in Mont Clare. The banks of the Schuylkill River had swelled mightily, and the adjacent canal had been overcome. Several residents sit along the stone wall of the bridge that originally traversed the canal. The large building in the background eventually became the Mont Clare Market, a grocery store that preceded the produce outlet occupying the space today.

www.arcadiapublishing.com

Discover books about the town where you grew up, the cities where your friends and families live, the town where your parents met, or even that retirement spot you've been dreaming about. Our Web site provides history lovers with exclusive deals, advanced notification about new titles, e-mail alerts of author events, and much more.

Find Your Place in History.